CAREERS IN PHOTOGRAPHY

CAREERS IN PHOTOGRAPHY

Ted Schwarz

Contemporary Books, Inc.
Chicago

Library of Congress Cataloging in Publication Data

Schwarz, Ted, 1945—
 Careers in photography.

 Bibliography: p.
 Includes index.
 1. Photography—Vocational guidance. I. Title.
TR154.S35 1981 770'.23'2 80-68590
ISBN 0-8092-7019-6
ISBN 0-8092-7018-8 (pbk.)

Published by Contemporary Books, Inc.
180 North Michigan Avenue, Chicago, Illinois 60601
Manufactured in the United States of America
Library of Congress Catalog Card Number: 80-68590
International Standard Book Number: 0-8092-7019-6
 0-8092-7018-8

Published simultaneously in Canada by
Beaverbooks, Ltd.
150 Lesmill Road
Don Mills, Ontario M3B 2T5
Canada

Contents

Preface *vii*

Introduction *xiii*

1. Commercial Photography: Portraits, Weddings, and Architecture *1*

2. More Commercial Photography: Model, Glamour, and Fashion *33*

3. Law Enforcement Photography *49*

4. Press Photography and Photojournalism *57*

5. Scientific Photography *67*

6. Camera Repair *71*

7. Television Careers *76*

8. Audiovisual Photography *87*

9. Custom Processing Laboratory Work *90*

10. Gallery Work *95*

11. Fine Art Photography *100*

12. Where to Get an Education *109*

13. Publications *145*

Appendixes:
 1. Where to Buy Backdrops and Similar Equipment for
 Portraits and Models *149*
 2. Where to Buy Albums, Frames, and
 Photomounts *150*
 3. Postcard Companies *152*
 4. Markets for Freelanced Photographs *153*

Index *157*

Preface

It was dawn, a time when most people are either asleep or stirring reluctantly in response to the shrill cry of an alarm clock. The rising sun was like a fireball that seemed to singe the earth. As the light gradually brightened the sky, a model stood on a rock, spreading a billowing cloak of fabric back-lighted by the sun. Below her, a photographer was maneuvering for the best angle to achieve a colorful silhouette meant to delight browsers of the Sunday paper where the photograph would appear as part of an advertisement for a clothing boutique. . . .

The well-dressed man in the conservative business suit walked swiftly into the jewelry store. It was near closing time and the briefcase he carried indicated to the two clerks preparing to lock up for the day that he had just left work. They did not realize their mistake until he pulled a gun from his pocket, keeping it well hidden from any passersby, and

ordered them into the back room. Then he bound and gagged them, stripped the safe of the most valuable jewels, and walked out the door. It was not until two hours later, when a security service patrol made a routine check of the shopping area, that the helpless clerks were found and word of the crime reached the police.

Within a few minutes the jewelry store was being secured by law enforcement officers. Among those present were members of the scientific investigation unit, men and women armed with cameras and scientific instruments rather than revolvers and mace. Slowly, methodically, they began their search for clues. The store was photographed from numerous angles; then individual items, all potential clues, were recorded. A knife had been used to cut the bonds of the clerks, so one photographer began photographing the knots before placing the rope in an evidence bag. The type of knot used could provide a clue to a former occupation of the thief. The rope ends were also recorded and would again be photographed under a microscope in the police lab. There might be a way to link the fibers with a second piece of rope found in the possession of any suspect who might be caught.

Everyone at the crime scene paid deference to the police photographers and other scientific investigation unit officers. They knew that unless a suspect was caught immediately or there were witnesses to the crime, the subtle pieces of evidence—the way a knot was tied, a hair fiber left behind, or some other tiny item found at the scene—would probably prove his undoing. The pictures taken at the scene could be the key to a courtroom conviction weeks, months, or even years later. . . .

The sun was setting and the red rays made the streets a colorful carnival of neon signs and a multihued kaleidoscope of passing cars. The photojournalist, cameras at the ready, sat in his car, observing a transformation of the surrounding scene. Men and women who had hurried home to their families were being replaced by pimps, prostitutes, and street

hustlers of all types. In an alley, a youth gang was busily preparing chains, clubs, knives, and an occasional homemade gun for an impending fight with a rival group. Police officers, walking in pairs, nervously moved along the sidewalk, knowing that violence could erupt at any moment. In the midst of all this, the photographer would soon be working, recording the nightlife for a special report in the Sunday paper. The photographer would work alone, risking violence, the theft of equipment, and other harassment in order to obtain a story that he hoped would motivate the community to begin cleaning up the area. . . .

The heat of the desert sun was intense. The missile was in place and scientists were quickly making last minute checks of the rows of dials and switches on the instruments they would be using to test the new weapon. Soldiers and observation planes were everywhere, maintaining considerable distance from the missile, which conceivably could explode if there was a malfunction.

In the midst of the heat and the tension, an unusual high-speed camera was aimed at the missile. It was designed to track the weapon as it rose, shooting thousands of frames a minute, so that the stills could be studied for whatever information they might reveal. Other cameras were scattered about the area and installed in pursuit planes that would follow the course of the missile during its test flight. . . .

The hospital surgical center was filled with the sound of doctors and nurses discussing the latest television special, a recent tennis match, and every subject other than the patient on the operating table. A delicate, previously untried emergency heart operation was taking place. The patient, a man in his mid-40s, had endeared himself to the staff with his cooperative attitude and friendliness in the midst of overwhelming pain. His heart had stopped twice during the start of the operation and everyone was concerned that he might not survive. The casual banter was meant to relieve some of

the tension everyone felt, yet it was to no avail. Everyone knew that there were no guarantees with an experimental procedure. They also realized that if they made a mistake, they would need to know where it occurred so they could avoid making it the next time a similar case arose. If the procedure was successful, they wanted an accurate record of how it was done.

Every few moments there was a pause in the surgery as a masked, gowned man was called to the operating table. He was carrying single-lens reflexes and working with available light. The cameras had been cleaned carefully and were handled delicately so they would not contaminate the open chest cavity.

The photographer moved quickly, taking three to five images, then moving back while the operation proceeded. His work had to document the surgery, but he had to do it in seconds. Every minute the patient's chest remained open, the risk of death increased.

Finally everything was finished. The operation was a success and the photographer had full evidence of how it had been accomplished. The staff had a permanent training study so that patients needing the same procedure in the future would be exposed to more knowledgeable surgical teams. . . .

The skydiving photographer did not realize that his helmet-mounted camera was loose until the parachute opened and the shock jarred it free from its mount. The horrified diver watched the camera tumble forward, end over end, smashing into the ground far below.

Upon landing, the sky diver located the expensive instrument and tried to assess the damage. None of the glass had shattered, but the lens was out of line, the camera mount was bent grotesquely, and the photographer could not afford a replacement. Fortunately, a camera repairman was able to help. The mount could be salvaged, the lens realigned, and the entire body made serviceable again in a matter of days. The cost was a fraction of the new camera price and the

photographer realized for the first time how important an expert technician can be in the field. . . .

The kickoff was high, long, and almost offside. The opposing team caught the ball and the players moved up the field. The home team rapidly reached the carrier and soon the playing area was covered with a confusing jumble of bodies. For several seconds no one in the stands could be certain who had the ball or what was happening. However, people sitting at home knew what was going on every instant because the television camera operator kept her skilled eye on the ball. She never faltered from her role of bringing the play-by-play action to people many miles or even several states away. And the videotape she used ensured that instant replays could show the subtleties of even the fastest action. . . .

Such can be the experiences of the professional photographer.

Introduction

There was a time when only the adventuresome would even contemplate a career in photography. The equipment was massive, and special plates had to be made light-sensitive just moments before they were used. The photographer had to work with foul-smelling chemicals in the darkroom, carefully preparing the plate, then rush it into the camera while the client or subject waited. Portrait photographers forced their customers to sit for minutes with a head brace to keep them still. Photographers of scenery had to cart their equipment with them, often traveling with a bulky covered wagon that could serve as both home and studio for preparing the plates. Many photographers had to travel in search of subjects, and constant discomfort, both from traveling and from exposure to chemicals, was a way of life.

By the middle of the 20th century, photography was a respected profession split almost entirely between commercial work and journalism. Commercial photography included

normal studio activities such as portraits, weddings, advertising, and fashion, for the most part. Journalism meant working for a magazine or a newspaper, covering the world's events as they unfolded. Training for both fields involved some schooling but usually meant working in an apprenticeship type of program.

Today all this has changed. Photography of one type or another seems to have penetrated just about every field imaginable. You can make a career of police work as a photographer or work in a hospital, recording all manner of scientific endeavors. Photography is part of the space program, and major industries often have full departments devoted exclusively to this field. There are numerous job categories, all of which require special training that usually must be obtained in a structured atmosphere, through either residence teaching or home study. The only question is where to go and what courses to take to suit your particular interests.

The purpose of this book is to provide you with a broad understanding of the numerous careers available in photography. The chapters that follow describe the different careers available to someone who wishes to work exclusively with a camera, what is required on the job, and how you can train most effectively for such a field. Wherever possible, specific information is given concerning the type of work to be done, how to prepare a portfolio in order to apply for a job, and ways to present yourself to a potential employer.

Later in the book you will find information about a large number of photography courses available throughout the United States. Both resident and home study courses are discussed and, while this section is by no means all-encompassing, schools throughout the country are listed so that you have a basis for comparison.

For those individuals who wish to learn about the fields they want to enter on their own, information concerning equipment and books for self study is provided. I personally feel that equipment should be purchased locally whenever possible because this allows you to establish an ongoing

relationship with a dealer who can be of help with supplies as your business grows. However, I also realize that a number of you live in relatively isolated areas where your access is limited. The equipment guides in Appendixes I and II will provide some alternative sources. Please keep in mind that the fact that a company is mentioned does *not* constitute an endorsement of the firm by me or by anyone connected with the publisher. Businesses change as their personnel changes. What is a good business at this writing may prove less responsive than desired by the time you read the book. At the same time, businesses that are not listed or are ineffective at this moment may be among the best in the country by the time you read this book.

The same is true of course information. The college listing offered here is only a guide; you should check the current course offering at the schools that interest you once you are ready for training. Photography is new enough as a major in some areas that the quality is constantly changing. A department may expand, attracting more and more top people, or it may decline after the single well-trained, energetic professor involved in the program retires or relocates.

This book is also filled with surprises. The field of photography has become so vast that there are far more career choices than you might have thought possible. You will not only learn about many of these opportunities; you will also learn what potential employers are seeking in terms of training and experience. The information comes directly from the people doing the hiring, not from the schools that train them. Thus, you are gaining information that is usually inaccessible until after you have completed courses that might be inadequate for the job. By studying this book you will gain the latest possible information about job preparation for a career in one of the most exciting professions available.

1

Commercial Photography: Portraits, Weddings, and Architecture

The photographer who enters the field loosely known as commercial photography is greeted by a world in which time stands still. He or she might be photographing a fashion model at sunrise or a wedding at midnight. In major cities, a studio might specialize in just one area, perhaps limiting its work to weddings, portraits, or advertising. In small communities, the commercial photographer might take portraits one day, photograph the construction of a new motel the following day, shoot a wedding the next day, and record the monthly luncheon meeting of a fraternal organization on still another day. He or she must handle the broadest possible range of assignments in order to meet the community's needs.

Most photographers define commercial photography as that which involves portraits, weddings, school photography, fashion, advertising, and architecture. However, these are actually quite distinct categories, so we will break them down according to the volume of business done in each field throughout

1

the United States. We will discuss how one gets started in each area, the type of equipment needed, and where to obtain special training when this is necessary for a career. This chapter will also show how to get your first job should you want to work for someone else rather than freelance.

There are two ways to enter the field of commercial photography. One is to go to work for an established studio. The second method is to work as a freelancer, perhaps starting from your home.

Most photographers like to freelance before working for a studio because it is easier for them to obtain a better-than-entry-level job. A freelancer can show a portfolio of 8-by-10 or 11-by-14 prints or images that pertain to the studio's needs. These might be portraits, wedding shots, or the other subjects discussed so far. The work will show your ability to express yourself visually. Contact sheets will also be requested at this time so that the potential employer can see how you worked and how many pictures you have to take before you get what you are after. The potential employer wants to be certain that you do not waste film and that your portfolio of fifteen to twenty-five pictures represents typical work, not the very best you have taken over a number of years. You must be able to show that you will be cost effective for the operation.

The studio at which you apply will expect you to be able to work with any of the cameras the studio normally uses. This might be all 35mm equipment, or you might have 8-by-10 view cameras and other specialized optical tools. Training in a good resident school such as those listed later in this book will provide that type of background.

With such proven skills, you will be asked to start with fairly simple assignments. You might be one of two people to cover a large wedding or asked to handle school portraits of children on location. You will be limited in your customers compared with the man or woman who hires you until you show you can consistently deliver quality images. Yet you still will have much greater flexibility than someone who has not freelanced is liable to be permitted.

The person who has just expressed an interest in photog-

raphy or is a recent graduate of a photography school is going to be treated differently. He or she will be given entry level work that usually does not allow the person to handle the cameras. You will load film, position lights, change bulbs, arrange appointments, build sets, locate props, book models, and do other essential tasks. What you will not do is actually take pictures. It is only much later that someone will give you a chance. Some career-minded individuals hired at entry level will have to go to work for a different photographer before they will be offered a chance to shoot photos.

Because many studio owners hesitate to hire a photographer who has never done more than go to school, freelancing can be a practical way to start. The following pages will detail the types of work handled by studios and the ways in which to build a portfolio through moonlighting. Keep in mind that such moonlighting can be done part-time, while you are in school, holding another job, or raising a family. What matters is getting just enough experience to show that you are sufficiently competent to be given a chance to prove your worth behind the camera.

PORTRAIT PHOTOGRAPHY

Portrait photography once meant the ordeal of standing stiffly in front of a camera, usually with a brace holding the subject's head in a most uncomfortable manner. Films were slow to record light and camera lenses were of extremely poor quality compared with those available today. Exposure time was measured in seconds or minutes, and most work was done outdoors or in studios with vast expanses of glass to allow as much light as possible to fall on the subjects.

Over the last century, the business of portrait photography has changed. High-speed films, lenses that are optically excellent and have large f-stops, and the availability of inexpensive, portable lighting systems have made portrait photography a more relaxed experience. Many studios offer candid photos taken of children at play. Others still use rather formal poses,

but the subject is relaxed because exposures can be measured in fractions of seconds instead of interminable minutes.

Portrait photography is probably the largest business among studios throughout the United States. It requires a minimum of equipment and space while offering a service that is desired in every community. It is also a business many photographers enter as freelancers, often beginning in high school, taking pictures outdoors with available light.

A portrait photographer must be an outgoing individual who genuinely enjoys dealing with other people. The photographer must be able to put at ease the young and old, the corporate executive as well as the service station attendant. Your personality is being sold every bit as much as your finished product. Few individuals need a portrait taken more than once or twice a year at the most, so the experience must always be a pleasurable one. Otherwise, the customer will not return to you and you will find it impossible to build your business.

The simplest portrait studio can be established in your home on a part-time basis. The fact that you have purchased this book probably means that you are serious enough about photography to own most of the equipment needed to take portraits as a business. The only obstacle you might encounter is local zoning restrictions; however, these pose only a minor problem. A residential neighborhood will not tolerate a home studio if it means that cars constantly park on the street near your home, if you have signs and/or display windows visible on the outside, or if you otherwise create an obvious nuisance. On the other hand, if the studio serves walk-in traffic from the neighborhood and does not advertise blatantly, you can usually avoid complaints.

To photograph portraits you will need an adjustable camera, preferably with a lens that is longer than normal to reduce the apparent distortion created by moving in close with a regular lens. This means using a 90mm to 135mm lens on a 35mm camera or a 105mm to 150mm lens on a roll film camera. A 35mm camera with fine-grained film can be used,

but the roll film format is better for other reasons. Not only does the larger negative make retouching easier, but this camera also looks more professional because it is different from what your customers may own.

A list of possible equipment is given at the end of this section. However, if you do not own roll film equipment and want to buy it, consider such used items as the Mamiya Twin Lens Reflexes, which have interchangeable lenses, and the pre-electronic Bronica equipment, which has excellent mechanical shutters and high-quality optics and is readily available in larger city camera stores at relatively low prices. Such equipment also looks impressive and makes you seem more professional.

Portrait photography requires a minimum of three and a maximum of four direct lights. These can use inexpensive flood bulbs or they can be electronic flash units. A full-time studio should use electronic flashes for portraiture because they provide cold light that prevents your subjects from feeling as though they are enduring the flames of hell by the end of a 15- to 30-minute session. Studio electronic flash units come with what are known as modeling lights. A modeling light is an extremely low-wattage continuous light, preferably centered in the middle of the flash tube. It illuminates the subject and shows you exactly how the full light system will create areas of light and shadow on the contours of the person's face. This gives you the control of continuous lighting systems without the heat, because the truly bright light needed for the picture that is supplied by the electronic flash will be used for only a fraction of a second when the shutter is released.

The strongest light used to illuminate the portrait subject is called the main light. It is either the most powerful light you have in terms of output or it is equal in power to the others but placed closer to the subject. The second light is called the fill light; its job is to reduce shadows left by the main light. The third light is a hair light, and it is meant to bring out the contours and details of the head. The fourth light, if used at

all, is usually placed on the background paper to add extra separation between subject and background.

Some photographers use umbrella reflectors for their work. A large umbrella reflector provides a soft controlled light that can take the place of other lighting. Many photographers who use umbrella reflectors for their lights use just two lights. One is bounced from a large reflector and fulfills the bulk of the lighting needs. The second is bounced from a reflector that is either the same size or slightly smaller and handles all the fill-in needs.

In order to gain an understanding of portrait work and to develop your skills if this is your career interest, you should probably buy three to four inexpensive reflector floodlights that accommodate 500-watt photoflood or tungsten bulbs. The only difference between these two types of bulbs is their color temperature. A photoflood bulb is rated at 3,400 degrees Kelvin and is meant for Kodachrome Type A film (Koda-chrome 40, at this writing). Daylight is around 6,000 degrees K. and electronic flash units start at around 5,600 degrees K. A tungsten bulb is rated at 3,200 degrees K. and is meant for Ektachrome tungsten films and their equivalents. The higher the number of degrees Kelvin, the more blue the light contains. Since the tungsten and photoflood bulbs are only in the 3,000-degree range, a daylight film used indoors with such lighting will record everything with too much warmth. Red tones will dominate. The reverse situation exists when indoor film is used outdoors. All subjects will be too cold and blue tones will dominate.

The actual techniques of portrait photography are not part of the scope of this book. Such training is available through the schools listed in later chapters. It is also easily learned by reading books on modeling, lighting, and portraiture. However, I will go into the space necessary for this type of operation because this is one career you can begin immediately on a freelance basis.

A backdrop must be used for portraits. This can be as simple as a clean white wall or as specialized as a commercial

backdrop. The least expensive commercial backdrop is a roll of seamless paper. This is a roll approximately nine feet wide and several yards long that is suspended from a stand. The paper is unrolled to whatever length necessary. It is brought to the floor and pulled out for both full-figure model work and group portraits, or it can be lowered to a point just out of camera range for head and shoulders work. You can suspend the paper from a commercial stand or just hang it by pulling a taut piece of clothesline or nylon cord through the center of the tube. The cord can then be tied around cup hook loops screwed into the ceiling an appropriate distance apart. This is the cheapest way to set up a studio in the home.

The lighting you use can be quite simple. Some photographers start with clamp lights, inexpensive photoflood and tungsten bulb holders, that come complete with reflectors and clamp on the backs of chairs, your tripod, a broom stick, or almost anything else. They can also be attached to the wall through the use of Gaffer tape, a tape similar to duct tape that is sold in camera stores. Gaffer tape is meant to be attached to any surface with enough strength to support heavy weights. In addition, it is easily peeled from the wall without damaging plaster, wallpaper, or any other surface.

The home studio also requires a stool or low-backed chair for posing. The camera is mounted on a tripod and adjusted to whatever height is necessary. That is all there is to it. This arrangement is not much different from that found in a commercial portrait studio, though the equipment there is more elaborate.

Whether or not you do your own darkroom work is not important. It is usually easier to use custom labs, even after you own a studio, so you can spend your time away from the camera trying to increase your business.

Selling your work can be done a number of ways. You should have business cards made that identify you and your studio and include a telephone number. If the hours when you can be reached by telephone are limited, they should be listed on your card. You also might want to hire an answering

service or obtain an answering machine to take messages.

Freelancers working part-time usually put together a portfolio of portraits taken of family and friends. Perhaps ten black-and-white images and ten color images will be taken door to door in your neighborhood, along with your business cards. Your work is shown and a business card should be left behind. Eventually someone will hire your services and your door-to-door sales will be enhanced by word-of-mouth referral.

Appointments are scheduled for evenings, weekends, or whenever your studio is open for business. These are usually made thirty minutes apart, and you will need a place for people to wait if they arrive early. You can use the living room, family room, or any other part of your house, provided it will be undisturbed during your business hours. This is how many professionals started their photography businesses.

The prices you charge will depend on your costs. Many photographers follow the formula of charging 3½ to 5½ times their total costs, which include film, processing, proofs, prints, mailing, telephone, and depreciation of equipment, among other items. (Photofloods have a maximum life of six hours each, and a quartz light might last from twenty-five hours to seventy-five hours, depending on the unit.) You must be certain that you make a decent hourly rate for your efforts during the course of an average day. Naturally, your rates should be competitive with full-time professional studios. This means that your charges should be similar or higher, if the quality warrants. You should never undercut prices because of a lower overhead since raising prices later can cost you clients.

Four steps are involved in running a portrait business. The first is generating customers through door-to-door sales and advertising in newspapers, weekly "shoppers," on radio and television, and any other way you can obtain them. The second part of running the business is taking the portraits— the work done during the sitting time. The third involves showing the proofs to the client, and the fourth is the delivery of the final prints. Only the time behind the camera ensures financial gain, which must cover the cost of the time spent

doing other work. When you have a studio, you will have an employee who functions as receptionist/secretary and does everything else necessary to free you for behind-the-camera work. Until then, you are on your own.

Photographers who decide to establish a home business will need up-to-date information concerning taxes, legitimate deductions, and other financial matters. Your local Internal Revenue Service office will have a number of pamphlets meant to help you understand the various applicable tax laws. These are revised as needed and should be checked for subtle changes. For example, there was a time when you could deduct a room frequently used as a home studio. At this writing the room must be used exclusively as a studio and you must take photographs there several days a week to prove its business value.

Photographic equipment costs have to be deducted over a period of time. You cannot buy $5,000 worth of cameras, then take that sum off your income tax the first year you have them. The regularly updated pamphlets will supply the information you need.

The Social Security Administration can also provide information concerning deductions, proper withholding if you use an assistant, and disability information.

Contact your local city hall and state office building to learn about zoning restrictions and other potential problems. For instance, you may need to charge a city or state tax when you sell portraits and similar commercial work.

An accountant, especially a CPA who is also a lawyer, can be of great help. Have such an individual establish your bookkeeping system and conduct an annual review of your taxes to be certain you are meeting obligations plus gaining maximum benefits within the law.

Your greatest expense will usually come with establishment of the bookkeeping system. The periodic consultations needed thereafter, which take only four or five hours of time a year, should require only minimal expenditure and are considered a legitimate business deduction.

If you want to do portrait photography full-time, you

should either take courses at one of the schools mentioned in this book or find local courses. You will need to know business management, basic tax law for small businesses, and advertising, promotion, and marketing methods. Fortunately, most colleges offer such individual courses, and mastering the information is simple.

Equipment

Roll film cameras are preferred. The Mamiya RB67, the Mamiya Twin Lens Reflex lines with interchangeable lenses, and the new Bronica and Mamiya cameras using a scaled-down roll film image are all ideal. Most can be purchased cheaply if you buy a used camera. Older Rolleiflex Twin Lens Reflexes can also be purchased used, though they do not allow for full lens interchangeability. The most expensive lines are Hasselblad and the new Rolleiflex SLRs, which use roll film. However, older Bronica S series cameras with mechanical shutters are equally valuable for this work and are fairly inexpensive when purchased used. Larger format cameras can be used with roll film backs. If you use 35mm, stick with fine-grained films such as Kodachrome and Panatomic-X.

You will need from three to four lights on stands or two lights with umbrella attachments. Inexpensive photofloods last for six hours, quartz lighting lasts for up to seventy-five hours, and electronic flashes will last for several years. The electronic flash system must include modeling lights in each flash head to be effective.

A posing stool and backdrop are essential. The latter can be seamless paper, a white wall, or any other surface that records as a neutral color, not a specific object that might detract from the subject.

One type of portrait work is photography of babies and children. You will need toys, balls, and other props to occupy the children. You will also need thick soft carpeting or a large rug for the babies so they can crawl without hurting themselves.

WEDDING PHOTOGRAPHY

Wedding photography is probably the second most common type of commercial photography. It allows for the greatest profit for many studios, can be started at home much like portrait work, and is a delightful challenge for those who enjoy it. Training is not essential in terms of special schooling, since this is another field that can be learned through experience coupled with reading.

"I see myself as a journalist with a camera when I photograph weddings," said one midwestern photographer. "I am covering the world's most important news event. It is a once-in-a-lifetime story and the people involved may never be together again. The wire services are clamoring for my pictures, but the editors say that they must be artistically flawless in addition to capturing all the action of the day. In other words, I try to put myself in the perspective of the family and then I work my tail off to be as creative as possible, even though I've recorded the same type of event hundreds of times."

Whether or not you share this view, wedding photography does require the same sort of skills called upon by many newspaper photographers. Events unfold quickly and a missed image is lost forever. A ring is slipped on the third finger of the left hand only once. A bride stuffs wedding cake into the groom's eyes, nose, and mouth only once. Uncle Joe dances a jig at his favorite niece's wedding only once. You are there, and there is no shouting, "Just one more, please" during the ceremony. It is the kind of high-pressure work you will either delight in or hate. Most studio photographers love it, and it is second to portrait photography in volume handled by professionals.

Wedding photography, like portrait work, can be self-taught. It is basically a news photography concept, though special effects devices such as star filters and vignetters are often added to the camera. The operation of special effects devices can be learned from manufacturers, from books, and through special wedding seminars held around the country.

Information about such seminars and other training can be found in the appendixes. Once again, Chapter 12 provides information on in-depth training that will help prepare you for weddings.

Wedding coverage can only be as thorough as the budget of the bridal couple will allow. Payment includes an hourly fee for the photographer, the cost of all materials, a markup that usually runs to 3½ to 5½ times cost, and a fee for overhead. The billing, however, does not list such a breakdown. Most studios figure how many images they can take to show as proofs, as well as how large an album they can provide for a set fee. Thus, a wedding package might sell for $150, $300, $500, or whatever. The package will include whatever the photographer chooses, such as an album of twenty 8-by-10 prints, an album of proofs that is usually no larger than 4 by 5, and perhaps a single 11-by-14 print of the bride mounted in a frame. The proof album includes all the pictures taken, and the album of 8-by-10s represents a selection from the proofs. Thus, there might be well over 100 proofs, even though the large album is greatly narrowed in scope. The remainder of the images are enlarged and sold to order if the family wants them.

The least necessary photographs are often the most interesting. These are the ones taken before the bride reaches the church and are the least desired when the bride is on a limited budget. You will need at least two full hours for these, counting transportation time to the church, synagogue, or other location for the ceremony. This extra time and the cost of the extra film add greatly to the final bill for the bride. Many families cannot or will not want to pay for this. But the photographer must be ready to offer this service because some families treat a wedding as a major event on which several thousand dollars are spent. The family may go into significant debt by choice, considering the wedding as important as the expenses of a college education or a new home.

The photographer works as a silent observer. He or she follows the bride around, including staying in the room where

she adds the final touches after finishing dressing. The bride is recorded both alone and with her family. Nothing is posed. As much as possible is photographed with available light. Flashes should be available as a supplement. The camera serves as an all-seeing, all-recording presence; the photographer should not try to direct the action to get a better photo.

The photographs shot in the home are especially touching when they capture the parents and the bride talking, touching, and otherwise interacting. There may be last-minute tears or the pleasure of jokes relating to the past. A ragged old teddy bear sitting on the table where the bride is putting on makeup may provide the kind of visual contrast that makes for a photograph cherished by the family for many years to come.

There is no better place to take meaningful pictures than at the bride's home, and this fact often makes a strong selling point for the family. Such pictures capture the meaning of the rite in a way that the ceremony itself never will for the client. This is the moment when the family accepts the reality of the change in their lives. The daughter has become a woman and is about to become a wife and equal partner in her own home. You are there to capture the experience and it is a moment that will never be forgotten.

The second part of the wedding is the ceremony itself; this includes pictures taken around the ground of the facility used for the service. These shots should always be taken, but again, the degree of thoroughness will depend on how much the client wants to spend. For example, if a larger budget is involved, you should also take behind-the-scenes photos that show the groom and his friends and the bride and her friends.

I once covered a wedding in which the bride was terrified. I had never seen anyone so pale before a ceremony, and the pictures reflected this fear. The groom, on the other hand, was standing around, joking with his friends. Immediately after the ceremony, the bride relaxed and seemed to glow. She was radiantly happy, while the groom looked white and terrified. Such images recall delightful memories for family and friends.

The true work at a wedding starts with the procession. As a

wedding photographer, you will have to fend off children at play, Uncle Harry with his Instamatic, and Aunt Clara with her Hasselblad in order to position yourself to capture each member of the wedding party as he or she comes down the aisle. (Half the cameras at weddings are made for amateurs and the other half are going to be better than the professional ones. Unfortunately, the owners of these expensive cameras may not be particularly expert in their use.

Photographing the procession is usually done with flash on camera, one picture per couple. Most photographers either use an automatic flash or prefocus on one spot on the aisle, then take the pictures as the couples reach that point. The problem is that family members with cameras often step in front of you for their own pictures, and this has to be handled with some diplomacy.

You may or may not be allowed to photograph during the ceremony. Photos taken at this point usually have to be taken with available light, which is no problem with today's high-speed films. Some photographers have deliberately switched to almost silent cameras, such as the Mamiya Twin Lens Reflex and the rangefinder 35mm cameras such as Leica, in order to ensure silence in the church. Single-lens reflexes are frequently so noisy that they are embarrassing. The quiet shutters allow for freedom of movement without disruption of the ceremony.

At a church wedding, photographs are again taken during the recessional with a flash. This is handled fairly quickly because the pace is faster and the work must follow the traditional kissing of the bride.

The period between the ceremony and the reception is an ideal time to photograph the families. This should be done quickly, before the couple gets into the receiving line, where they will be kissed so often that the bride's makeup is mussed.

You should take shots of the bride and groom alone, the bride with her parents, the couple with the bride's parents, the couple with the groom's parents, the groom with his parents, the wedding party, and every other combination you can get. The more people you photograph, the more pictures you will

sell. By isolating the bride and groom with different parents as well as together, family feuds will not take precedence over who gets which pictures. Great Aunt Lottie may have always hated the groom and refused to acknowledge his existence, but she'll leave the bride in her will if the picture she gets just shows the bride with her parents, the groom and his family not included. Other family members will want pictures of everyone. Obviously, the more variations you record, the greater the number of potential sales.

Next you shoot the receiving line, followed by the rice throwing, the bride tossing the bouquet and the garter, and any other ritual that is part of the wedding. Certain ethnic groups have unique customs, and the wise photographer will consult the person who officiates at the service well in advance in order to be prepared for whatever will happen. Many successful wedding photographers obtain reference books and/or maintain their own records on different wedding ceremonies and customs to use as guides. Something that can easily be overlooked by a photographer who is unfamiliar with the action could be a key part of the client's ritual and very important to the family.

At least two cameras are essential for weddings, and you should bring twice as much lighting equipment as you would normally expect to need. Remember that this is a news event that will never be repeated in exactly the same way. You cannot let camera failure provide an excuse. You have to succeed the first time. Even on a low budget, many photographers will have a fairly large electronic flash with a high-powered battery pack to allow for fast recycling, then also use a small portable unit that fits in the bottom of the gadget bag as an emergency backup.

The final stage of the wedding is the reception. Some photographers like to wait until the reception to take group pictures of the family, but most consider this risky. The bride and groom have been kissed 8,000 times; half the bridesmaids have mascara running down their cheeks; Grandpa has gotten drunk, chased some of the young girls, and been carried out

semiconscious yet with a smile on his face; and confusion reigns everywhere. When this occurs, formal pictures are a disaster. However, casual images taken of the guests and the family as they dance, drink, eat, talk, and otherwise enjoy themselves are easy to get and highly salable.

Wedding photographers incur tremendous expenses right from the start. The cost of film alone is high, and extra film must be carried in case the unexpected occurs and more pictures than normal must be taken. Even before the family can order any work, the photographer has spent money for film, processing, and printing of proofs. This can add up to well over $100 in the case of a large wedding.

Most photographers insist on payment being made in from two to three parts. An advance fee is paid on the day of the wedding. This is handled by either the groom or the best man. The fee is a fraction of the package price originally quoted. For example, suppose the family has agreed to a $300 package for the wedding. This package includes one or more albums of proofs (sometimes three proof albums are purchased—one for the couple and one each for the parents of the bride and the parents of the groom) plus an album of 8-by-10 or 11-by-14 images (8-by-8 and 11-by-11 in the case of a square roll film format). The cost to the photographer for all this is $100 and the profit and overhead come from the remaining $200. The overhead in this case includes all costs, including the hidden price of depreciation, other than lab work and film buying. Under such a circumstance, a check for $100 will be requested for the day of the wedding, with payment to be made at the reception to ensure that the photographer shows up for all events.

The fee covering your costs is always called something else when you mention it to your clients. Most photographers call it either an advance or a retainer. Whatever you call it, avoid telling the family that it is intended to cover your costs. This would alert them to the high markup and they might object.

The next time the photographer meets with the bride and groom is after the honeymoon. At that time, you sit down

with the couple and perhaps the bride's family to show the proofs. There was a time when proofs were unfixed images that would fade when exposed to light for very long. Today's proofs are simply small prints, usually machine-made. They are 4 by 4 or 4 by 5 in most cases and are mounted in a proof album, which is nothing more than a standard album for small prints. Some photographers stamp the word "Proof" on each image, using a special ink which can be wiped clean. However, this is an unnecessary task.

The proof album contains every decent image taken of the wedding, far more pictures than would be included in the final 8-by-10 album for most bridal couples. If the arrangement calls for your base price to cover an album of twenty-five 8-by-10 enlargements selected by the bride and groom from the proofs, the actual number of proofs might be three or four times that figure. The family may be able to choose from 100 or more smaller images, each of which you have prescreened. You will throw away the blurred picture, the one in which Aunt Hazel's head blocked your view at the moment you released the shutter, and all the other mistakes. The proof album should contain only those shots that seem perfect so that your reputation is enhanced. Never mind the fact that you blew a number of images. Everyone does. The important point is that the family doesn't know this.

Once the selection is made, many photographers ask for a second payment. This can be a token fee or a sum equal to half the remaining money due. Whatever the amount, it should be high enough to cover all your expenses when coupled with the first check, even if the family orders more prints than were part of the original agreement. The latter situation occurs frequently, since no one can decide how to narrow the proofs to the number allowed in the original price for enlargements. Additional prints are purchased on an individual basis at whatever fee you arrange.

Finally, on the day of delivery, the remainder of the money is to be paid in full. Photographers working with both very low-income families and very high-income families often try

to set up credit options, such as payment through one of the bank card companies. This allows the families to make a larger commitment than they could otherwise afford or might otherwise make.

The best way to start a freelance career is to knock on doors in order to get your first wedding. You will need samples of your work, whether you eventually want to be part of a wedding studio or freelance. Unfortunately, wedding photos involve more planning than putting together an architecture portfolio, for which you can select any building at any time and record it at your convenience. A wedding requires coordination with families, the person performing the ceremony, the hall manager, and anyone else involved. Thus, it will take some planning.

One approach is to utilize friends or acquaintances. Find out who is getting married. If you are confident in your abilities, suggest that you photograph at cost, making no profit, but being allowed to use the pictures as part of your portfolio. You should take many more photos than normal under such circumstances, covering every aspect of what goes on so that you are assured of a broad range of samples from which to choose.

If you are not confident of your abilities, you do not want to put yourself into a position of being the only photographer at a ceremony. I made this mistake at my first wedding, a wedding meant to give me a portfolio that would launch my career in this field. Not only did part of my flash synchronization die, but I also used equipment that required me to filter my lens. The trouble was that I combined the wrong filter-/film/flash arrangement and ended up turning the bride's white dress a lovely shade of blue; her gentle complexion turned from peachy pink to deathly purple. Fortunately, I was able to print some black-and-white images, which saved me somewhat, but the family hated me and I felt terrible about insisting that no one else work the ceremony. If I could do it over again, I would have worked in conjunction with whatever photographer might have been hired based on experience.

I should not have worked alone that first time when I really was not confident of my abilities.

Working simultaneously with another photographer does, however, present some ethical problems. The other photographer will be an active professional in this field. He or she will be relying on the wedding income as a living. If the family buys fewer photos from the professional because you are there as well, this is totally unfair. Under such circumstances you should make it clear to both the family and the professional that you are there to obtain a sample portfolio, not to compete. You will neither sell nor give your work to the family until well after they have finished their financial arrangements with the professional. At that time you will give them either a proof album or one or two framed enlargements as a way of thanking them. You will not give them material that would reduce what they would purchase.

Wedding coverage by two photographers should be coordinated so that you do not stand next to each other or get in each other's way. Both of you will want pictures of the wedding party coming down the aisle. However, you should position yourselves so that neither of you blocks the other and so that you can each use flashes for separate images of the same situation without both flash units being triggered at once, overwhelming the couple with too much light for your camera settings. Neither one of you must guide the other, and you should neither try to duplicate what the professional does nor ask endless questions. Remember that you are there to build a portfolio that will eventually enable you to compete with the other person. That is a potentially tense situation at best.

If you can't find someone who is getting married, there are three approaches to finding strangers who might cooperate with you. The first is to advertise your need in area college newspapers, weekly shoppers' flyers or the personal section of your daily newspaper's classified advertising pages. Have brides call you and see what you can arrange.

The second approach is to talk with clergy in your area.

Explain what you are doing and see if they can help you contact brides. Some will be cooperative and others will refuse to talk, the response usually being based on how the photographer handled himself at the last wedding where the clergy officiated.

The third approach is to watch for engagement announcements in your daily newspaper. Then contact the couples until you can find someone interested in cooperating with you.

Again, you should have business cards made and be sure that there is a telephone number at which you can be reached. This is similar to what you would do when building a portrait business before starting your own studio or going to work for someone else.

Eventually you will have to advertise and contact engaged couples in order to build the wedding business, so the legwork you do in order to gain a sample portfolio will pay off. It will teach you marketing techniques that will also be valuable to a studio, should you apply for a job in this field.

In order to go into the wedding photography business full-time, you do not need a formal education. You can teach yourself through a combination of reading and experience as described earlier. However, courses taken through mail-order study or a two- to four-year resident training program do help because they give you broader exposure to the field of photography and business. It is a good idea to take courses for small businesses in your community such as those offered through adult education programs. Marketing and advertising basics are also helpful to learn. These not only enable you to succeed on your own, they also make you more valuable to a potential employer. Wedding photographers also can take advantage of periodic traveling training programs available to them; and these are advertised in the various professional journals listed in the appendix of this book. Taking these will expose you to new concepts and techniques.

Equipment

Any camera that accommodates interchangeable lenses can

be used effectively for weddings. My preference is for cameras that are fairly silent, because they allow you to take pictures unobtrusively during the ceremony. Many photographers utilize the Mamiya Twin Lens Reflex for this purpose since, at this writing, such a camera is the only nearly silent roll film camera available. It combines interchangeable lenses and a large negative. Other photographers rely on equipment ranging from the Olympus line to Leicas.

A camera such as the Hasselblad or the 2¼-by-2¼ Bronica is frequently seen at weddings because such heavy-duty units are reliable workhorses. However, they are noisy and the sound may result in your being asked to refrain from taking pictures during the most solemn parts of the ceremony, times you most want to record. A camera as quiet as the Mamiya or the Olympus can be used from a corner where you are not observable even when there are certain restrictions against photographing.

An electronic flash unit is essential for weddings. The least expensive will have no automatic features but a 510-volt battery pack, which allows for recycling in as little time as one second. These are ideal, though you will have to learn to estimate distances and experiment at home to make certain you can take pictures quickly at different distances with the proper exposure. Tests should be run at set distances to determine the actual light output, since the rated output may be more or less than the actual delivery ability. This occurs with all flash units but is most likely to be a problem with nonautomatic units. Fortunately the test of bracketing exposures need be done only once.

The second electronic flash unit, carried as a backup, can be a simple device using double A batteries. Extra batteries should be carried, but such a unit, automatic or manual, will be utilized only if all else fails.

Additionally, at least three connecting cords for the flash units should be carried. These are the weak links in this type of equipment and often the first item to die. Having three cords ensures that you will have the least chance of experiencing any problems.

The most sophisticated wedding operations use multiple-

flash techniques involving an assistant who holds a second electronic flash coupled with a slave trigger. The light from the first flash unit reaches the trigger, firing the equally powerful second flash. The action occurs so quickly that no light is lost. A third unit is carried as a backup.

The only other items needed to get started in wedding work are the sample albums that you can obtain from local companies or those listed in Appendix II. This type of business actually requires the lowest overhead in terms of equipment purchased.

ARCHITECTURE PHOTOGRAPHY

Photographing architecture rarely fills an entire career; rather, it is usually one part of a commercial studio's operation. This is due to the limited size of the construction industry, which prevents most commercial studios from specializing in architecture. The few studios that do photograph architecture exclusively usually have clients throughout the United States and, occasionally, throughout the world.

For commercial studios that do this sort of work as a sideline, there are actually three types of architecture photography. The first type is handled with small cameras and is done almost exclusively for real estate agents. This involves the photography of the exterior and/or interior of homes, apartments, and commercial buildings. In some cases a single photo is needed to accompany a listing. In other cases, the inside is included in a photo series that is used to sell the home or office to a prospective buyer even before the customer has seen it. A number of organizations around the country offer advice to individuals selling homes on their own. The homeowner pays a flat fee rather than a percentage commission and the company prescreens the potential buyer by showing slides of the interiors of homes in the appropriate price range and location for the interested buyers. Then the buyers are sent to view only those homes that are of interest based on the slides seen. Area photography studios are hired to do this work as new listings are added.

The second type of architecture work is done to advertise or promote new buildings as well as to provide records for the contractors, architects, developers, or tenants. For example, suppose a new hotel opens in your area. A commercial studio will be hired to photograph the structure. Such photos may be used to advertise the hotel, often through illustrated postcards, to promote the builder, to decorate the walls of the corporate headquarters of the firm(s) involved, or for similar purposes.

The third type of architecture photography requires sophisticated equipment. It is the photography of high-rise structures and other buildings where accurate reproduction, strict attention to detail, and great enlargement potential are necessary. This requires specialized cameras allowing for major lens adjustments known as swings and tilts. Such cameras may be view type, mounted on a monorail, or they may be the press type, such as the Linhof and Calumet Horseman.

What most photographers, including working professionals, fail to realize is that architecture photography usually does not require special equipment in order to render a building accurately. A commercial photographer using normal 35mm and roll film cameras that do not allow for perspective control can handle most of the demands for architectural and real estate photographs. This is made possible by a single trick that is known by far too few professionals. This simple secret can open the architecture field to you regardless of the equipment you own.

In order to photograph the exterior or interior of any building without distorting it, all you have to do is to keep the film plane parallel to the perpendicular sides of the building. You will get distortion only when you tilt the camera to take in a high-rise or other unusually tall structure. If you can take the pictures you need without tilting the camera, something that is always possible with houses and is usually possible with most other buildings, the pictures will be flawless. A view camera with its swings and tilts cannot do a better job.

The key to architecture work lies in the difference between

view cameras and cameras with rigid lenses: the view camera has a bellows that allows you to change the angle of the lens without altering the camera back. The film, located in the back, remains parallel to the perpendicular lines of the building. However, the lens, mounted on the adjustable bellows, is angled upward. Then, through careful adjustment and a small lens opening, which allows for greater-than-normal depth of field, the image is focused on the film plane and recorded as though no corrections had been made.

With a rigid lens camera—a normal single-lens reflex or range finder camera—there is no bellows to allow the separate tilting of the lens. Some compensation can be made by using perspective control lenses, but these are not only expensive on their own, but also are available only for the costlier cameras, such as Nikon, Canon, and similar lines. Again, as long as you position yourself so that you can record the entire building while holding the camera with the film plane (camera back) parallel to the perpendicular lines, you will have no trouble.

Photographers who use their usual cameras for architecture and real estate work prefer moderately wide-angle lenses of 35mm and 28mm with 35mm cameras. Even the least expensive of these will prevent any hint of distortion when used properly. A 21mm lens is better, though some inexpensive optics do allow edge distortion at best, curving what should be straight lines. The side of a wall may seem to bend slightly, creating an image that will not thrill the typical builder commissioning your pictures.

Wide-angle lenses allow more of a building to be viewed without having to tilt the camera to fit it all in. Most of these lenses work perfectly with buildings of no more than four or five stories, even from a position fairly close to the building. The farther back you are able to stand, the higher the building that can be recorded without special equipment. This can be a problem in a city, but it makes taking pictures of most homes fairly easy.

There are two ways to handle the exterior photography of a

building. The first is to handle it in the normal way. You frame it in your viewfinder, make certain your camera's film plane is parallel to the perpendicular lines of the building, then take the picture. Next you begin to look for different angles, perhaps framing the image with foliage, parts of other buildings, or anything else that enhances the picture.

The second method for handling exteriors is used when you lack perspective control equipment but need to record a high-rise that cannot be handled in full without tilting the camera. Under such circumstances, you make no effort to record the building in its entirety. Instead, you isolate visually interesting sections. For example, one image might be the unusual entrance, perhaps framed with shrubbery or an overhang. Another image might be a close-up of sculpture or unusual design work on a portion of the building. Yet another angle might capture some of the building through some flowers or trees.

Instead of taking one picture of the entire exterior, you take several pictures of key elements. These provide the same total information and the client never realizes that you are not equipped to take a single image. It is a way of handling equipment shortage without having to turn down a chance to make money. It is also a method you will need to know if you choose commercial photography as a career. Architecture is likely to be just one of many activities in which your studio will engage in order to survive.

The great advantage of architecture for photographers is that it requires little overhead. No studio is necessary because all work must be done on location. In addition, the majority of assignments will involve using either available light or a limited amount of supplementary lighting. For example, for many years I handled interior lighting with the same inexpensive floodlights needed for portraits. The only additional expense I incurred was for extra-long heavy-duty extension cords because all outlets were inevitably found five feet farther away than I anticipated.

Most offices have well-lit interiors. Unfortunately, these

lights will probably be fluorescent, which presents a slight problem. Fluorescent lighting is normally a rather odd color spectrum that results in images with a distinct green cast. The odd coloring cannot be changed, no matter what type of film you use. The only way to counteract this when shooting color is to buy a fluorescent light correcting filter for your lenses. Flesh tones will not be so accurate as could be achieved with tungsten lighting and tungsten film, for example, but they will not make the corporate executives look like men and women recently arrived from Mars. Such green skins should be expected with uncorrected fluorescent lighting.

There are two methods for handling interior photography. The first is with a flash on the camera, the flash head bounced against the ceiling to ensure a fairly even illumination of the room. This method is used by many photographers who handle real estate photography. Most real estate firms handle houses whose commissions will not justify hiring a photographer to shoot each interior for more than an hour or two at most. The photographer must be able to get in and out quickly, even though the results may be inferior to what could be achieved with more attention paid to careful lighting.

The second method is to work with supplemental lighting as needed, using floods or quartz lights—the same type of equipment used for models (see Chapter 2). Several electronic flash units can also be used, but the cost is prohibitive for most photographers. Equipment that allows for high light output, modeling light attachments, and portability can be quite expensive. Quartz lights, with seventy-five-hour life spans, are much more practical and easier to handle.

When working with controlled lighting, the photographer should first walk around the room to be recorded, studying the existing light and adjusting anything that will cause problems. For example, if sunlight streams into the room from an open window, there may be harsh areas of light and shadow. Such a circumstance will require you to bathe the shadow areas with your extra lighting, close curtains to shut out the sunlight, or wait until noon to work, a time when the sun will be directly overhead.

Light meter readings should be taken in every corner of the room in order to determine the proper exposure. This is easy to do with a hand-held incident light meter, which you hold so it is pointed toward the camera. A reflected light reading can be taken from the carpeting, from a neutral grey card available from most camera stores, or even from the palm of your hand. If you do not have a separate meter, take the reading with your camera, using the built-in meter as though it were a hand meter. Remember that a built-in meter used from your shooting position will only record an average reading for the room. This will not be accurate when the light is uneven. You want to make certain that all corners are lit evenly enough so that the image will record as planned. You do not want to have some sections turn black from shadows while others are washed out.

Care must be taken so that extension cords and light stands are not visible in the final image. This is done by carefully checking your viewfinder before taking the picture. The lighting is best either when it is bounced or when you extend the stands to the ceiling, positioning the lights so the illumination covers the widest possible area.

Try to dominate the light so that one film or another records best. By this I mean that if there is sunlight coming in from the window, it will be blue while the tungsten lighting in the room will be reddish. A daylight film will not record accurately unless you supplement with blue flood bulbs in addition to the existing tungsten. The blue light of the floods combined with the daylight will dominate the remaining tungsten. The light will result in fairly accurate color when you use daylight film. The alternative would be to bring in enough tungsten lighting to overwhelm the daylight so that artificial light dominates the room and a tungsten film records the most accurately.

Always take far more film than you think you will need if you have to use color film when handling small camera architecture. I feel you should carry film sensitive to daylight plus film sensitive to tungsten light when you don't know just what you will encounter. I carry enough of each to handle any

circumstance. This way I can use any type of light I encounter, supplementing as necessary. I also carry extra-high-speed film in case the light level is worse than anticipated.

Take photographs from several different angles in the room. Use a tripod and a wide-angle lens, raising and lowering the tripod, using a stool for yourself when necessary, in order to see how the room will record from different angles. Your film plane must remain parallel to the perpendicular sides of the walls, which prevents your taking a position where the camera will have to be tilted. However, by raising and lowering the tripod, even from the same position, you will notice that the room's appearance changes radically. This can be most effective for creating different views from the same general location when the room is small and maneuvering is difficult.

Be certain that you know what is important and what is not when recording a new home or office. You will often find that the coordination of furniture and plants has been carefully planned, either by the architect or by an interior designer working with the architect. A careful recording of the room, showing the furniture, perhaps a wall hanging, and other key elements, may result in additional sales to the person who arranged such items.

Security systems are being installed in more and more business offices, and you should take care to find out whether they can be shown to the public. For example, I once photographed the interior of a bank that had some television cameras carefully hidden by wall decorations. After I photographed the interior, working for the effect of the design and paying no attention to security, I had to take my enlargements to the architect for checking. Every print that showed part of the security system could not be used for publication. Only those pictures that gave no hint of the security cameras could be used.

Office photography must be coordinated carefully with the manager of that office. Care must be taken so that the people shown are employees and not the general public unless the client specifically wants the public shown. Usually, when the

public might be recorded, the images are taken so that everyone other than employees is shown from the back. You might show a bank teller from the front, the image taken so the customer's back is to you. You might show a nurse taking care of a hospital patient, the patient's face turned away from the camera. This is done to avoid getting model releases as often as possible. A release is necessary when the picture will be used for advertising, and releases are much easier to obtain from employees than from customers.

Large format equipment, such as the 4-by-5 view camera, is needed for only two reasons when recording architecture. One is because the final use will require extreme enlargements. However, this situation can often be handled through the use of extremely fine-grained film and roll film equipment. A used 2¼-by-2¼ Bronica S has not yet reached the status of a collector's item and is thus available as inexpensively as a fairly cheap, new 35mm single-lens reflex meant primarily for the amateur market. Yet the Bronica or some other camera that is equally old, equally undesirable in terms of modern sophistication, and equally capable of producing razor-sharp enlargements, will enable you to make wall-sized prints. I have seen excellent photo murals covering vast office walls produced by such cameras and fine-grained film.

There are other times when the image must be cropped or an unusual enlargement must be made when nothing other than 4-by-5 film will suffice. Such equipment must then be rented, purchased, or borrowed, or the assignment must be refused. When you are starting at least a part-time career in this field, refusing an assignment you can't handle without special lenses is often the best way to ensure that you keep overhead expenses to a minimum.

The second case when such cameras are necessary is when the building is so high that the lens must be tilted and special compensating adjustments made. This requires a bellows with the adjustments for raising, lowering, tilting, and swinging the lens for compensation. It also is a circumstance in which a special lens must be used to ensure that it can cover a wider-

than-normal area when radically twisted for adjustment. Naturally, the camera must allow the film plane to be consistently parallel to the perpendicular lines.

Some architecture photographers have discovered that the adjustments they have to make for tall buildings can be handled by a press-type camera with a rising and falling front. Such cameras have other features that give you additional versatility yet do not quite reach the level of sophistication of the full-view camera. Such equipment is made primarily by Linhof and Calumet Horseman, and used models are relatively inexpensive. Photographers find that the roll film versions of these cameras often provide all the adjustment and enlarging potential they need. The equipment records either a 2¼-by-2¾ image or a 2¼-by-3¼ image, depending on the model. The roll film used is the same as that needed for a Mamiya Twin Lens Reflex, a Rolleiflex, a Bronica, a Hasselblad, or a similar model. Thus, you can own an adjustable press type camera for architecture and a roll film camera for portraits, weddings, stage photography and the like, and still be able to make quantity purchases of just one type of film. This results in discount purchasing and reduces overhead.

As mentioned earlier, architecture photography is normally not a career in itself. It is one aspect of a studio's operations, and this means that such images should be part of your portfolio. Half a dozen pictures should be included with your portrait and wedding work when you apply for a job with a commercial studio.

If you plan to freelance, your portfolio shown to real estate agencies, architects, and others should be fairly broad in coverage. There should be home photos that could be used to sell the houses, high-rises (if you can handle them), hotels, and commercial real estate such as business offices and the like. The greater the variety you present, the more areas for which you will be considered by the potential clients. At least twenty images should be part of your portfolio, and you should have separate color and black-and-white sections to show versatility.

There is no training for architecture photography that is truly practical, even though it is taught in both home study courses and most resident programs. You will learn more about lighting and the use of view cameras, both areas of knowledge that you will need. However, you are also going to have to understand what the architect and contractor feel is important when you record a structure for someone other than a real estate company. This requires that you learn a little more about the subject either through reading books about architecture, including the autobiographical work of architects such as Frank Lloyd Wright or by talking to architects about their work. For example, one builder of custom homes with whom I have worked likes to use wall mirrors to add apparent depth to his houses. A room becomes endless because of the mirror-reflected space. Thus, the mirror is an important element for photography as well.

Equipment

A 35mm camera and fine-grained film can be used effectively for architecture work. Moderately wide-angle lenses of 28mm and 35mm are essential with such a camera, though a well-corrected 21 mm is even better. Inexpensive 21mm lenses may not be corrected properly and can cause some curvature of straight lines to be evident at the edges of the frame.

Roll film cameras allow the greatest versatility. Again, wide-angle lenses such as the 40mm and 50mm lenses for cameras taking a 2¼-by-2¼ image are needed. The least expensive used equipment includes older nonelectronic Bronicas, the Mamiya RB67 and Mamiya Twin Lens Reflex cameras. Adjustable lens cameras in this format include the Linhof Technika and the Calumet Horseman. You might also find some 4-by-5 cameras of this type that have roll film backs. However, these may not be as easy to use as the cameras specifically designed for roll film.

Lighting should basically be the same as might be used for portrait work. However, electronic flash equipment will prob-

ably be either lacking in portability or too costly for the light output. I prefer quartz lights, which have a seventy-five-hour life and accessories for extra versatility. You will need heavy-duty extension cords in at least twenty-five-foot lengths. You can never own enough extension cords because you can never be certain of where the electric outlets will be.

Fluorescent light compensating filters should be purchased for those lenses you might normally use for office photography. These are not perfect, as different fluorescents give different color temperatures. A purist would want to add filters according to the specific lights encountered. Unfortunately, handling the problem in this manner is too expensive as it requires a color temperature meter and special correcting filters that must be carried everywhere, even though many may not be used. The single correction filter will work effectively for most purposes.

Any light meter will work effectively if handled as discussed in this chapter. Hand-held incident light meters are easiest to use. Some photographers like to buy a system-type incident meter, which allows for conversion to a spot-type reflected light meter. Such a spot meter attachment will enable you to record the shadow detail of a building interior when the detail is located in an area where a direct reading is impossible. This is especially helpful at night.

2

More Commercial Photography: Model, Glamour, and Fashion

There are other areas of commercial photography in which you can make your career. Remember that in smaller communities the commercial photographer handles everything that comes along, as described in chapters 1 and 2. In major cities such as New York, Atlanta, Cleveland, Chicago, Detroit, Los Angeles, and similar areas, it is possible to specialize in just one of these areas. The necessary courses, or the training you must give yourself, remain the same whether or not you are able to specialize.

Model photography is a term I use loosely to cover model, glamour, and fashion work. How this is handled depends greatly on your area. For example, in New York, fashion work often means working for garment manufacturers. In Cleveland, it may mean photographing the finished clothing for a department store catalog. In a small town of just a few thousand people, it means taking a black-and-white image of items available from a local specialty shop for newspaper

advertising. In every city, the work can also involve the regular recording of fashion shows put on by department stores, boutiques, and charitable organizations.

Model work can mean taking portfolio pictures for men and women who are receiving modeling school training. It can also mean working with models who are displaying products for advertising and public relations work.

Glamour photography often has a slightly disreputable image because nude work is frequently included in this category. It is true that taking pictures of nudes and pinup-type images for magazines, calendars, and posters can be part of this business, especially if you freelance for magazines and poster companies. Yet glamour also includes the photography of attractive men and women to create an image for a fur salon, an expensive restaurant, a nightclub, or some other location.

Taking pictures for a model's portfolio involves all the techniques you will need for every other aspect of glamour and fashion photography. Thus I will go into detail concerning such work so you can get a clear understanding of what will be expected. The training is consistent, with the exception of the fashion photography field. Many photographers find it helpful to take courses beyond normal photography fields to help them with fashion. They may go to a modeling school to learn a model's tricks for moving, information they can convey when working with both amateurs and portrait customers. They may also take courses in fashion history and design. The more you understand about clothing, the easier it will be to record it effectively and imaginatively when circumstances allow.

Model photography can be handled with any camera you own even though some people have specialized preferences. One photographer will tell you that a motor drive is essential because the model is constantly in motion. Another photographer will point to glamour specialist Peter Gowland's regular use of 4-by-5 equipment of his own invention and say that large-format transparencies are essential. Still others will

say that if you have not mortgaged your home in order to own a Hasselblad and a complete line of lenses, you can never enter this field. Fortunately, the truth is that your present equipment, if it allows interchangeable lenses, is probably completely adequate.

Most model photography can be handled on location. When you must work from home, you will need the same type of studio discussed for portraiture. Basically this consists of a background such as seamless paper and three to four supplementary lights. The total cost for such additional material will be between $100 and $200 and is really not necessary. You will find that you can work on location if you are careful about which assignments you seek.

A model needs to have a number of different images taken in order to put together a portfolio that bespeaks versatility. Such a portfolio, consisting of 8-by-10 or 11-by-14 prints, will show head and shoulders images, different hairstyles, full-length images in different types of clothing (formal wear, casual styles, bathing suits, etc), and character pictures. The latter might be anything from a variety of costumes for an actress or actor, to pictures in which the model is using a product of your selection. In the latter case, the person might be sitting on a power lawn mower, riding a horse through the woods, working out in a health spa, or even using one of your cameras as though he or she were demonstrating the product for an advertisement.

Model work can be handled easily on location. Drive around your area and study the scenery and buildings. Parks and playgrounds are ideal settings for model photography. A shaded area provides even illumination while the sunny sections can be modified by using reflectors to fill harsh shadow areas. Such reflectors can be commercial products, such as special umbrella devices sold by Larson Reflectasol, the Spiratone Company in New York, and numerous others, or they can be homemade. I have successfully used large pieces of cardboard covered with either a white cloth or aluminum foil. These are angled just out of camera range and aimed so

they reflect light into the model's eyes or whatever part of his or her face is deeply shadowed.

Are there old homes and offices with elaborate columns, ornate carvings, or other design elements that are visually interesting? You can often use such locations for posing. The same is true with museums and even large office complexes in high-rise buildings. In some cases you will need to obtain permission from the management, but if you work quickly, avoid disrupting the normal flow of traffic, and use no flash or tripod, usually no one will mind. Flashes are disturbing and a tripod poses a traffic hazard because people can trip over one of its legs.

Shopping malls can be ideal settings for model photography year-round. A covered mall may have garden areas, interesting designs, and all manner of ways to isolate backgrounds. If you work when business is slow, you are not likely to be disturbed. Some stores and restaurants may even have managers who will let you come inside during off hours in order to take advantage of the different setting.

Older business districts in your community can make good location backgrounds. Ancient wood and the design patterns of fire escapes often are interesting elements when photographing a model. The important point is for you to be constantly aware of your surroundings, thinking about how the backgrounds might be utilized during both good and bad weather.

The model will have clothing and other props to carry. A professional photographer working with models for a clothing store will be supplied with the items the model is to wear. When you record a model solely for his or her portfolio, he or she will be expected to supply the clothing. In either case, you should get into the habit of treating the clothing properly to ensure that it is not damaged or marked in any way. Every good habit you develop at the start, even before you have decided that this is the career you want to follow, will make such behavior automatic later on.

Department stores and clothing specialty shops do not have

clothing specifically designed for photography. The manufacturers do not supply samples to fit the models. Instead, they take standard retail merchandise off the rack long enough to allow you to record it; then they want to be able to return it to the rack, undamaged, for sale as new merchandise. This means that you have to prevent it from being damaged.

Professional models are trained in ways to handle clothing to prevent damage. Unfortunately, the photographer is the person who will be blamed for any destruction, so you must be aware of certain precautions. It is only on those occasions when a representative from the store handles the transportation of the clothing that you are absolved of responsibility. Such circumstances are rare.

Clothing must not be allowed to become wrinkled. It should never be worn while going to or from the location where pictures will be taken. The model should not sit in the clothing except for posing. She should also not lean against the wall or any object that will leave marks, paint flecks, or do other damage to the clothing. The exception is when such poses are part of the concept of the photo and are approved in advance by the person supplying the clothing.

Makeup is applied before the model gets dressed. She should place a thin scarf, such as one of chiffon material, between her lips, then drape it over her head. The clothing is pulled on with the covering over her head, then the scarf is removed. If there is any need for slight retouching, she should completely cover herself with a large towel to avoid soiling the clothes.

The model must also wear perspiration shields to prevent stains from appearing under the arms. You should plan to purchase these items for use by the models. You can not assume that he or she will supply them.

Locations should be planned so that the model can maneuver as much as necessary without snagging the clothing. Care should be taken when working with two or more models that makeup from one does not smear onto the other.

The model should always dress wherever you will be working. Sometimes this means having the model change in

the car, under a large blanket brought along for this purpose. Other times the model may have to use a clean rest room. Whatever the case, make certain that the clothing can always be protected and that the model will have privacy for dressing.

A beginning model may have no idea of how to pose. The same problem arises when handling fashion work for small stores where professional models are not used. You may find yourself trying to direct the store owner's daughter or perhaps the members of an area social organization, none of whom understand posing. Unfortunately, even the most skilled photographer may not be able to guide an inexperienced model.

There are two simple approaches to handling posing with a model who is new to the field. One is to use a technique known as the clock face. The model stands on both feet, pretending he or she is in the center of a clock. Then one foot becomes an hour hand, moving forward to point to each hour, from one to six or six to twelve. Then the foot is returned to the center of the clock face and the other leg is extended for the different positions. The body takes on different positions naturally with these changes.

The second approach is to obtain pictures of models or others doing what you want your subject to do. Clip advertisements from newspapers and create a file of images with models in interesting poses. You might also buy a book showing basic ballet dancing because ballet requires a dancer to move in every possible position that is both graceful and visually interesting. Having your model imitate such poses will allow you to concentrate on framing and taking the pictures rather than giving directions.

Your photographs should have at least two areas of emphasis. One is the model. Your work should display the model's versatility in as many ways as possible.

Your photographs should also show products, including fashion, and how the model handles them. Can the model effectively wear clothing so that the material is desirable to the person viewing the image? Can the model hold a product in a way that emphasizes its sales appeal? Your work must show

these skills, emphasizing the object or fashion rather than just the person doing the demonstrating.

There are certain tricks many photographers use to enhance the appearance of a model when demonstrating clothing. Most clothing will be from the model's personal wardrobe, in which case fit should be no problem, or it will be off the rack. In the latter circumstance, carrying a supply of spring-clip clothespins will help. Fabric can be clipped with the plastic pins in order to change its shape. A garment that is slightly too large at the waist or bust can be narrowed to give the illusion of a perfect fit by clipping a portion of the fabric just outside the camera range.

Lighting can be varied to bring out texture or color. A sidelight, the illumination along the edge of the fabric, will bring out the texture. A soft light, perhaps a flood bounced from the wall, ceiling, or a reflector, will emphasize the color of the garment and play down the texture.

Color affects the eye when working with fashion. You are naturally drawn to warm colors such as red, orange, and yellow. The eye perceives cold colors, such as blue and green, as receding. When a model is photographed holding towels or a similar item for a client, the product will often be in a warm color while the model may be dressed in dark blue. Your eye is drawn to the product and not to the model, who seems to recede even though both the the model and the items he or she holds are actually on the same film plane.

Color can sometimes work against you. If you are trying to emphasize the model and she is wearing a red skirt, the eye will be drawn away from her face if her blouse and any head covering are cool in color. A better way to draw the viewer to the model's face is to have her wear a red blouse or scarf and a red headband or similar item. Your eyes will then be drawn to the area between the two red objects and the viewer will focus on her face. It is a subtle difference, yet one which can make or break a sale for portfolio use.

It is easiest to use color negatives for model photography because you have the option of printing in both black-and-white and color. However, color prints cannot be sold for

publication and you may want to try to market some of the
images you take. Color slides can be made from the prints, but
this is an extra step that can result in reproduction that is less
than perfect. I prefer to take both black-and-white film and
color slides, making prints from the slides for the model's
portfolio, a step which costs the same as printing from
negatives. The contact sheet for the black-and-white shots is
inexpensive and only the most desirable images need to be
printed. The model can use a magnifying glass to study the
contacts, making a selection in that manner.

The lighting problems are similar to those encountered
with portrait work, and the accessories you will need for your
home studio session are the same. Reading books on lighting
will help you understand different techniques. Just be cau-
tious about following them too closely. Most books will tell
you that the perfect light for model photography of this type
is what is known as butterfly or glamour lighting. The main
light is high and angled downward, creating a tiny shadow
just underneath the nose. Because of the shape of the nostrils,
this shadow appears similar in shape to a butterfly. Thus the
term butterfly lighting is applied to this approach and many
photographers swear by it. I have even known schools in
which photographers must use only this technique to pass the
glamour lighting section of their course.

The reality is quite different. No single lighting approach is
perfect for every type of model. Glamour or butterfly lighting
might be ideal for the face of one person and terrible for
another. I have seen models whose portfolio pictures showed a
horribly exaggerated nose caused by the use of such lighting.
It was the wrong light for the model.

My answer is to walk around the model, moving the light
up, down, and all around as I go. I study his or her face to see
what is most striking. Then I position the light at that
location and fill in from there. Each time I alter the light, the
change is meant to illuminate the model in the best way
possible for the individual. Sometimes this is butterfly light-
ing. Frequently, it is not.

The model's portfolio will consist of up to twenty-five prints that are either 8 by 10 or 11 by 14. Anything smaller than 8 by 10 will be too small to seem professional. Any prints larger than 11 by 14 will be too massive to be viewed comfortably in a smaller office.

Warn the model to limit all the pictures in his or her portfolio to either color or black and white, or to mix them in sections. The first section will be all black and white and the second section will be all color. Alternating color and black and white detracts from the impact of the black-and-white images. The eye is drawn to the color, and highly dramatic black-and-white prints are overlooked as a result. Having a portfolio in which all the black-and-white prints are viewed before the color images are seen will show both methods to best effect.

A composite differs from a portfolio and is another aspect of model photography. A composite is a single sheet of paper designed to fit into a standard file folder. It might be 8½ by 11 or 17 by 11, then folded to the 8½-by-11 size in order to give four sides for showing images. There will be from one photograph to a maximum of four images per side. Thus you will have from two to sixteen pictures reproduced on what will be a handout serving as the model's calling card. The model will have his or her name, basic measurements (height, weight, dress size, shoe size, hat size), special sales points (member of American Federation of Television and Radio Artists, member of the Screen Actors' Guild, or similar union affiliations allowing for commercial and stage work), telephone number and, if with an agency, the agency name and address, all in the lower corner of either the front or back side. This necessary information often makes using just a single image on that side a necessity, with up to four images on the reverse. The composite is left with each potential employer as the model's calling card. It is the means by which the potential user of his or her services will remember the person and be able to get back in touch.

Most photographers prepare the composite at the same time

that they record images for the portfolio. The best portfolio images are printed separately for use in the composite as well.

Model portfolios and composites are needed by both modeling students and working professionals. They must also be changed regularly, and this means greater income for the photographer. In major market areas such as New York, Cleveland, Atlanta, Houston, Los Angeles, and elsewhere, the portfolio is changed every six months or whenever the model radically alters his or her hairstyle. In other areas, just an annual change is essential if the hairstyle remains the same.

A variation of the portfolio is a type of work found in smaller communities, where modeling schools do not exist, as well as in the large areas. This involves pictures taken for a model's personal use when he or she is not really a professional. Many commercial photographers record fashion shows in which trained amateurs are involved. Small-town dress shops and department stores might use employees, high school students and/or women within the community who are often socially prominent. These individuals buy prints for their own memories. Because such work often involves grabbing the images during fashion shows rather than under more controlled conditions, the material may be out of place in a serious professional's portfolio.

Most fashion show work is done while the models are demonstrating the clothing. The photographer positions himself or herself with a flash, catching the model at the point when the clothing can be recorded most effectively. Sales are made to the sponsor of the show, the manufacturer, the models and the store(s) involved. In larger cities, where a designer may have custom-created each item, this individual will buy prints as well.

Fashion show photographers must rely on one and preferably two flash units. Two units provide better lighting for the garment but require either an assistant or a special holder with a slave trigger attached to the flash. The slave trigger is like an electric eye that attaches to the flash unit without a connecting cord. When the flash attached to your camera is

triggered by the shutter mechanism, the light emitted strikes the slave sensor on the second unit and triggers that flash. The speed of light is so rapid that both lights illuminate your subject while the shutter is open. Often one flash will be held by the photographer on one side of the runway and the second flash will be positioned on the opposite side. The model must pause and turn at the end, the movement making for an ideal picture.

Sometimes a store wants advance publicity and a minishow is staged for the photographer's benefit. Seamless paper and light stands can be brought in, or you can work in the same runway area that will be used for the public show.

The photographer seeking such business must first put together a portfolio of images, working as effectively as possible. If you cannot afford to hire a professional model or if you live in an area where this is impossible, find someone attractive who is willing to work with you in exchange for a token fee or, preferably, just for prints at cost. This might be a friend, neighbor, waitress, student, or almost anyone else. Put together a series of photo sessions until you have images that fit your needs. Then start making the rounds.

The people to see include advertising agency account executives and art directors, fashion department and publicity department heads in department stores, the owners of specialty clothing shops, and similar individuals. You might also contact the manufacturer of clothing promoted on a cooperative basis in your area.

A cooperative advertiser is someone who works with a seller. The seller agrees to place the manufacturer's items prominently in the store's advertisement in exchange for money to offset the cost of the ad. For example, suppose a department store wants to stage a promotion on jeans made by Levi-Strauss. If that company agrees to a cooperative advertisement, the newspaper advertisement would offer nothing but Levi's products and would state that they are available at the specific department store. No other products and no other Levi's outlets are mentioned, even though dozens of competing stores

in the same community might offer them. Thus, the manufacturer gets extra advertising space and the store gets a larger ad than it might be able to afford if Levi's wasn't picking up part of the cost on a cooperative basis.

The advantage to the photographer comes from the fact that a picture might be desired when the cooperative promotion involves either a fashion show or a window display. The fashion show photos or window display photos are sold to the store, which sends them to the manufacturer or distributor as proof that the store's side of the arrangement was carried out. This means more business for the commercial photographer handling fashion work.

Nude and pinup work is not a routine assignment for a commercial photography studio even though there is a legitimate market for this type of photograph. Some images are sold as calendars, including custom-made calendars which businesses use as advertisements. A manufacturer of automobile parts might have a custom-made calendar that includes a scantily clad woman holding one or more of the products. Or the calendar, though bearing advertising copy, just shows a pretty girl in an attractive setting. She might be nude or dressed sexily and riding a horse, for example. Whatever the case, the work is handled tastefully and is in no way pornographic.

Many photographers sell such work through stock agencies that have clients throughout the world. Others try to publish in magazines such as *Playboy* and *Playgirl* in the United States and similar markets around the world. Whatever the case, changing moral values, new attitudes concerning what might be considered sexism, and other problems make this work an avocation at best for almost all professionals. It is also a narrow or nonexistent aspect of a commercial studio's work.

Advertising and public relations jobs are also part of the commercial photographer's domain and advanced training can be of help in these fields. There are numerous ways to light a product, including such technical tricks as front and rear

screen projection. The photographer projects a slide of a subject, color, pattern, or whatever seems appropriate. This becomes a background for the subject and/or product. It is a method of bringing unusual images to the studio when this would otherwise be impossible. A photographer working in Alaska during a blizzard can pose a model in a bathing suit by the seashore using a rear projection screen and a slide of a warm coastal region.

There are sprays that can be applied to extremely shiny metal objects to reduce the surface glare. There are also specific ways to record food so that it photographs perfectly, even though it might actually be undercooked or improperly prepared for eating. Such tricks are learned most easily and thoroughly through special training and hands-on effort. This means attending a residence training program or special seminars available through groups connected with the Professional Photographers of America (Chapter 12). You might want to attend a residence program connected with a college, or you could take a home study course. I do not recommend the latter approach if your equipment is limited because it can make the learning more difficult. Food is recorded best with an adjustable large-format camera (some photographers do use 35mm single-lens reflexes such as Nikons and macro lenses most effectively) and someone to show you proper food preparation. Major studios offering this specialty employ a food stylist who is trained to make food look appetizing and desirable for the camera. Trying to teach yourself is a slow process that often proves impractical.

All photography courses aimed at professional photography as a career teach you how to light and record various items besides food. The only other area for which residence training is more practical than home study is magazine illustration. This is the field in which you create an image that dramatically grabs the eye. For example, one illustration I saw used in an advertisement for audio equipment showed a turntable with a human arm and hand clutching a knife in place of the standard tone arm and needle. It was a contrived

image, and the technique used to achieve it requires training and a variety of equipment. It is also the type of work that only a few individuals can handle and for which demand is limited primarily to the major advertising centers around the country. It is not a common part of commercial photography for the majority of photographers.

Public relations work is handled almost exclusively on location and can be learned by doing. You will need the same knowledge of supplemental lighting as that required for real estate and portrait work.

Most public relations photography calls for visually telling the story of a business or industry. You record whatever you find happening. This may mean photographing throughout a hospital, recording everything from surgery to research to daily patient care. Or you might go to a steel mill and trace the path of production, recording hearth furnaces, pours, testing, and the other aspects of the industry. Or you might walk into a business office and show the routine work being accomplished. Pictures will also be taken of executives, new buildings, and redesigned interiors. Whatever might be affecting a company should be shown by your photographs.

Public relations photographs often end up in brochures, annual reports, traveling displays, lobby hangings, and the like. All the images are meant to promote understanding of the company and, at times, to improve the public attitude toward the operation.

Putting together a public relations portfolio is easy. Select a number of area businesses you feel would be visually interesting to record. Then start talking with the owner or office manager and see if you can obtain permission to take pictures. Explain that you want the work for your portfolio but will sell individual pictures to the company if interested. Should they use your services, they are getting results without paying for the time you spend recording everything. They may choose not to buy anything, in which case you still leave with the images you needed for your portfolio.

Once you have a portfolio, you will need to contact the directors or office managers of the various businesses involved.

Sometimes they will look at your work and make the decision whether or not to hire you. Other times they will refer you to a public relations agency handling this type of work. When an agency is used, an account executive handles the purchase of photographs.

The same portfolio images will be shown to the heads of photo studios when you want to work for someone else. Either way, obtaining the material is relatively easy.

Many commercial photographers are involved with school photography. In terms of skills needed, this is a combination of portrait work and public relations photography. The photographer might take pictures of individual classes or of individual students taken one at a time by classroom. For the latter, a seamless paper or similar background is set up, and a stool and lights are used. In effect, a miniature portrait studio is created for whatever time it takes to record the entire school. Faculty and staff are also photographed during this session.

Many school photographers also put together yearbooks that involve recording different events throughout the year. Sports will be photographed, as well as school plays, club meetings, and other activities. This is usually done under contract for a flat fee plus profits from the sale of additional prints to the students.

Some photographers also prepare church directories, which are similar to school yearbooks. These are visual records of the churches and synagogues, the members, staff, religious leaders, buildings, and activities.

The only specialized capability the school photographer needs is a way to record large numbers of students as quickly and efficiently as possible when taking individual portraits. You can use 35mm equipment, as many photographers do, or 70mm backs for roll film cameras. However, studios featuring this type of work as a specialty often go so far as to buy special portrait cameras. These have long rolls of film to enable them to record several hundred pictures at a time. These are not essential, however, and you can easily work all your life without them.

Still other assignments are handled by commercial photog-

raphy studios, but those discussed above are the basic ones common to the majority of studios around the country. Specialization is possible in larger markets, with some studios handling only portraits, others exclusively photographing weddings, and still others working with fashion, advertising, or architecture. However, versatility is the key to success for the majority of commercial photographers. They must be competitively competent in a variety of skills in order to handle every potential assignment within their communities. These skills can be self-taught or learned through specific training programs. Either way, business courses are essential because the studio is very much a business, not just a creative outlet.

3

Law Enforcement Photography

Television may never make a hero of the police photographer, and few crime movies even reveal the existence of such a profession. Yet if you are interested in law enforcement and have a good eye for detail work, such a profession may be the photography career for you.

The actual requirements for police photography vary from police department to police department around the country. Some cities train police officers to do such work. Other cities utilize civilian employees for lab work and scientific investigation, though they train their detectives in surveillance photography. The latter training comes through courses such as those offered by Eastman Kodak and those described in Chapter 12.

Unfortunately, the information you are about to read in this chapter will not be as comprehensive as I would like it to be. Most departments with which I spoke are in a state of flux. Their approach to hiring police photographers today will

change over the next year or two. Thus, I can only quote those involved to give you an idea of the scope of the duties you will have, not to show you how to join a specific department.

If you seriously want a job in law enforcement photography, talk with the chief of the department in which you are interested. Find out how the scientific investigation or other photo service works. Learn what type of background you must have in order to be considered, then obtain that training with the help of the school guide in this book (see Chapter 12).

Also contact the Law Enforcement Training Division of Eastman Kodak Company, 343 State St., Rochester, NY 14650. Ask about special instructional material and seminars held both in Rochester and elsewhere around the country.

Eastman Kodak's Professional Division has a number of books of interest to individuals involved with forensic and law enforcement photography. Contact this division at the above address to get a list of publications available from your dealer and directly from Eastman.

In general, you will be expected to have a background that shows an interest in photography, if only as a serious amateur. You will also have to show an interest in law enforcement, in some cases by joining the department and serving from one to two years in the uniformed division before requesting a transfer. You might also be expected to study basic law enforcement at an area junior college or university. Advanced photography training is a plus, but the law enforcement courses are more important to take. All the departments have ongoing educational programs that provide the technical knowledge for specialized needs.

For example, Chief William Hart of the Detroit Police Department explained about some of the photographic needs of his department. He stated, "Photographic evidence of crime scenes is the responsibility of the Evidence Technician Unit of the agency. This unit, which is comprised of experienced and trained police personnel, is responsible for the collection and preservation of all pertinent physical evidence found at crime

scenes. In addition, the Evidence Technician Unit has the responsibility of providing a permanent record of scenes through diagrams, personal notes, as well as photographs.

"Evidence Technicians receive a comprehensive training course in techniques of evidence identification, collection, and preservation at the Detroit Police Academy before being assigned to the unit. This training includes forty hours of instruction in basic photography, as well as crime scene photography. The objective of this portion of the program is to provide knowledge in techniques to display a scene accurately.

"Candidates for Evidence Technician training are screened for suitability on the basis of a number of factors. These factors include performance history, prior training or experience in photography, and seniority. The training is offered on the basis of department need.

"In addition to the above, selected sworn members attend seminars in advanced forensic photographic techniques. These seminars are conducted by the Kodak Corporation of Rochester, New York; the FBI Crime Laboratory of Forensic Photography in Quantico, Virginia; and the Michigan/Ontario Forensic Photography Workshop offered through the Hazel Park (Michigan) Police Department."

The Miami, Florida, police department relies on civilians to handle most of its photography needs. A full-color laboratory is maintained and scientific skills are more important than police background. However, when surveillance must be handled, it is usually done by actual police officers, often detectives, who are totally separate from the technical section of the department.

In Atlanta, Georgia, the men and women who are invovled with evidence gathering, analysis, and photography are both civilians and police officers. Some of the police officers have been retrained, usually at the request of an officer who likes the specialized work. An officer who has been retrained will earn more money than a civilian doing similar work and this can be a source of irritation within departments around the

country. This situation usually is resolved when either re-
trained police or civilians are phased out so that everyone has
the same background.

Some departments have technicians who are skilled in color
and black-and-white processing and printing, with police
officers handling all other work. In such cases, knowledge of
processing and printing will get you into the department and
give you a slight edge when applying for a position as a
police officer so you can do other phases of scientific investiga-
tion.

Typical of the background required by some departments
are the requirements (current at this writing) for the Los
Angeles positions of photographer, senior photographer, and
principal photographer. The distinctions are reflected in salary
and skills. All of them will eventually have to understand
motion picture work, still camera work with a variety of
camera types, photomicroscopy, and numerous other special-
ized areas of photography. According to Los Angeles Civil
Service requirements at this writing, the photographer must
meet these criteria:

"Graduation from high school and three years of experience
in black-and-white and color still and motion picture photog-
raphy is required for Photographer. Experience of the speci-
fied type may be substituted on a year for year basis for the
required education.

Qualifications for a senior photographer are as follows.

"Graduation from high school and five years of experience
as a photographer, two years of which were as a Photog-
rapher on or in a class which was at least at that level and
provided experience in taking, developing, and processing
black-and-white and color still photographs and taking black-
and-white and color motion pictures are required for a Senior
Photographer.

The principal photographer must meet these qualifications:

"Graduation from high school and two years as a Senior
Photographer is required for Principal Photographer."

The photographers with the Los Angeles Police Department

are expected to handle everything from aerial to portrait work, identification, and cinematography, among other areas. Once again, specialized surveillance needs are most likely to be handled by working detectives.

One of the problems that can arise with police photography careers comes from an unrealistic expectation on the part of the individual entering the field. It is only the lab technician who can be said to be involved with pure photography. The lab technician is likely to spend full time in the laboratory, handling the processing and printing of black-and-white and color images. All other scientific investigation personnel must be ready to tackle assignments that are critical yet boring.

"I have been on many cases in which I had to get down on my hands and knees, take a magnifying glass, and go over a floor inch by inch, searching for a hair. I've spent hours moving in a carefully planned way in order to miss nothing that might later solve a case. And believe me, a hair or something equally small can send someone to the gas chamber. This job takes patience and the enjoyment of detail in addition to the fun of the photographic work. If someone is just interested in the picture taking, I don't want him in my department," said the head of one scientific investigation unit.

Fire departments are similar in their needs, though they seldom hire anyone specifically to take pictures. Arson investigation is handled by specialists within the department who are chosen because of their proven proficiency in other areas. The photography is taught at that time, usually through courses held by the FBI, the Eastman Kodak Company, and others.

No matter where you live and what the regulations of the police department in which you are interested, certain training is always helpful. The most obvious is law enforcement training, as opposed to photography training. Most junior colleges and many universities offer both basic law enforcement training and a certain amount of law enforcement administration education. Both fields of study are excellent. In

addition, it will help if you take a good general photography course. Many men and women go through home study photography training at the same time that they are studying law enforcement. Then, when they apply for a job, they will have the type of background that makes them most valuable to the department. However, in most cases, they will still have to go through the basic police academy program. They will also receive special advanced training when they actually become involved with photography as part of the scientific investigation unit. This background is excellent and will give you a slight advantage no matter where in the United States you plan to work.

An alternative to joining a police department is to become a forensic specialist as part of your normal studio work. In very small communities the police and fire department may call on your photographic skills for ongoing cases. In most areas, though, you will not work for the police. Instead, you will work for insurance companies, lawyers involved with litigation, and similar parties.

The best way to become a forensic photography specialist as part of a commercial studio operation is to follow a similar route as that for police work. Study basic law enforcement in addition to becoming skilled in photography through residence or mail study. Contact Eastman Kodak in Rochester to learn about the company's seminars in forensic photography. You might also talk to your local police chief to learn if he or she can supply you with some of the addresses of periodicals aimed at police officers. These contain articles of interest, plus advertisements for training seminars. Among such periodicals are *Police Chief* magazine, *Law and Order* magazine, and various patrolmen's association publications.

Eastman Kodak also has special movie and slide programs for training. These include such basics as *Crime Scene Photography* and *Basic Photography for Fire and Arson* as well as such sophisticated training films as *Identification through Radiography*.

You can order several regularly updated publications

through any dealer stocking Eastman Kodak material. These include books such as *Fire and Arson Photography* and *Photographic Surveillance Techniques for Law Enforcement Agencies.* Such material serves as an ongoing refresher course after your basic education.

Forensic photography handled as part of a studio's operation is usually done after the fact. A building burns and the arson investigators have cameras on the scene almost immediately. The evidence needed to build their case is handled at that time. The general public, including insurance investigators, will not be admitted until all work is done, evidence identified, and similar matters handled.

The commercial studio photographer handling forensic work will be sent in by the client, usually a lawyer or insurance company, to record whatever seems pertinent to the case. This might mean recording the building in relation to others around it, with special attention given to the most severely burned sections. In the case of an auto accident, the photographs would show where it occurred, body damage on the cars, remaining skid marks, road conditions if possible, obstructions that might have blocked the driver's view, and similar aspects. A burglary case might require photos of the building, points of entry, surrounding conditions that would either hide or reveal a burglar, and any other appropriate shot. The pictures are used to help eyewitnesses remember better, show why someone was probably guilty or innocent, and even raise reasonable doubt concerning the conclusions of law enforcement experts. You might also be called on to photograph bruises and other marks on the victim of rape, assault, or other physical violence.

The commercial photographer handling forensic work seldom, if ever, is involved with surveillance work of any type. This falls into the realm of a private investigator, a field that is quite different. Surveillance work for private investigation can get into areas of questionable legality that you will want to avoid. Such work is not a field career in itself, but part of private investigative work and outside this book's scope.

In conclusion, if you are interested in law enforcement photography work, you must talk to members of the department in which you want to work. The requirements vary with each department even though their jurisdictions might cover adjacent cities. Then take whatever specialized training they require. If you do not know where you want to work, a two-year or four-year course in law enforcement coupled with a good general course in photography will be an ideal background. Just be certain that the photographic training includes darkroom information. If you take a home study course, be certain that you try processing color as well as black and white so that you have some experience, no matter how limited.

Photographers who wish to add forensic or police photography to their services should contact Eastman Kodak Company concerning training. You should also talk to your local police and fire department chiefs to learn about seminars for professionals in the field. Often someone who is working in the area but not part of a city department will also be allowed to take such courses. They are well worth consideration.

4

Press Photography and Photojournalism

The image of the photojournalist has traditionally been that of the globe-trotting photographer dressed in a trench coat, with half a dozen battered, motor-driven cameras hanging around the neck, recording assassinations in Swazipagoland, wars in the Middle East, guerilla operations almost everywhere, and underwater colonies of cannibalistic pygmies at the North Pole. Clark Gable has been given a camera and an unlimited supply of film, booze, and broads. Or if the photojournalist is a woman, she is Katharine Hepburn at her gutsiest, living in the trenches, sharing the showers, pursued by admirers, and always getting the best pictures in the midst of the most violent action.

I suppose that the image of the photojournalist does have its counterpart in real life. David Douglas Duncan or the late Margaret Bourke-White are well-known examples of such people.

The reality is quite different and even more exciting because

everyone can share in it. *Life* magazine is no longer a weekly news magazine and a few of the other major markets have folded. However, newspapers are spending more than ever on their photography departments, giving them new challenges and freedom. Specialty magazines abound as never before, so the total effect is one of tremendous potential for anyone interested in this field.

Almost all photojournalists begin their careers working for newspapers or newspaper wire services that syndicate their pictures to papers around the country. Some start on news and special interest magazines, but usually they begin with weekly or daily newspapers to gain background experience.

Newspaper photography involves three different skills. One is handling spot news, whether it be press conference, fire, crime in progress, or sporting event. You cover whatever is unfolding before your eyes, trying to take interesting, storytelling pictures about events you cannot stop, predict, or change.

A second aspect of newspaper work is illustrative. You must create a picture to go with an article or feature. This might mean finding an interesting way to record a vase or rare coin, the photography of a home with unusual interior design, and so on.

The third aspect of newspaper photography might be called the recording of the dull and boring. Emma Jones and six of her friends have just formed the Leisure Citizens' Gossip and Chowder Society and you have to find a way to photograph them all in a manner that is visually interesting. They are basically doing nothing but standing together in their best snapshot album poses. It is your job to change things enough so that, just maybe, someone will care. This is actually the most difficult part of the job because it is the least interesting for everyone except Emma and her friends. Other images of this type include "Presenting the Trophy," "Presenting the Check," "Presenting the Gold Watch," and equally uninteresting concepts.

Journalism has been an extremely popular field for college students ever since newspaper reporters became objects of

either admiration or ridicule for attacking the Nixon administration. Most colleges and universities offering this major also offer photography as a specialty within that major. The admissions personnel for such schools will convince you that this is the course of study you need. Editors of newspapers who actually hire photographers will convince you that quite the opposite is true. A journalism degree can almost be a liability when you apply for a job with a newspaper or magazine.

Publications editors want photographers who are knowledgeable about the world, versatile in their abilities to adapt to new situations, and technically skilled in the taking of pictures for publication. This means that while photography training and experience are important, especially through working for college papers or freelancing in your community, you will also be expected to have knowledge in other fields. Training in history, political science, sociology, and psychology will be respected far more than most journalism courses being taught. A certain amount of artistic training is also beneficial. The important thing is that you prepare yourself for photographing the world around you by taking courses that add to your understanding of the world, rather than those that tell you how a newspaper is put together.

There are several ways to begin a career in photojournalism. Every prospective newspaper photographer must have a portfolio of images and contact sheets that show how the person works. The editor will be looking for single prints with storytelling impact that can stand alone or serve to illustrate an article. The editor will also check your contact sheets to see if there is a clue to how you work. For example, suppose you have images of a fire. A skilled photojournalist will recognize that there is no way to know what he or she will encounter at the fire. Thus, the first few frames will be exposed while approaching the scene. There will be overviews of what is happening; close-ups, perhaps taken with telephoto lenses, of individuals and small groups of firefighters at work; images of emergency first aid, ambulance workers, people being saved,

the crowds, and so forth. Then, as the person moves in, the action will be narrowed. There may be one picture of a single fireman being given emergency first aid and a close-up of that fireman's face showing the agony of a burn. A second pair of images may capture a pet being rescued by a fireman on a ladder, then a frame showing a close-up of a tearful child hugging the animal.

The contact sheet will show all this. It will show how you work and whether or not you are aware that unpredictable page space will make two types of images essential. One picture must be a story in itself, an image that can carry a short caption and be understood completely without other details. The other picture will be a close-up that dramatizes one narrow aspect of what is happening and is used with text that is illustrated by several pictures. What is used will not be determined until close to press time, so the photographer has to cover both possibilities.

Naturally, the prints you show must be dramatic and tell a story. However, it is the contact sheet which can determine whether or not you get a job. The contact sheet shows how you think under pressure with the camera to your eye. It also shows whether or not you waste film recording everything in sight or whether you work to tell the story you witness.

It may be impossible for you to take dramatic spot news images such as those of a fire. Instead, you will have to substitute a story of your own creation. This can be as simple as taking pictures of an amateur theater group working during rehearsal, backstage in the dressing room, and then during the performance. You will still need the two types of images and you will have similar pressures since you will work as the action unfolds. This is also an important news-paper event.

A second type of photo series you will be expected to show will be a sports event. This can be football, basketball, baseball, or anything else involving unpredictable action. Again, you will be showing how you work under pressure. Such images can be taken at secondary school, college, or

professional games. They all offer the same lack of predictability.

Your portfolio should also include single images of the same type of work a commercial studio might handle. You might have some portraits, wedding photos, scenics, and so on. You will not need contact sheets for these and the prints should be in the minority. The main selling point to publication editors will be the contact sheets and prints relating to the action-type stories.

Some photographers obtain jobs right out of high school without gaining special training. They are self-taught and work for their school newspaper, freelancing for high school sports, little league action, and the like. These photographers might work for large city dailies, but they are more likely to end up working for small town dailies, weekly newspapers, and similar limited-circulation periodicals. They gain experience in meeting deadlines, working regularly under pressure, and making prints with adequate contrast for the poor-quality reproduction techniques of most small newspapers. Then, armed with samples taken on their own and for the newspaper, they move on to the larger city dailies after obtaining two to five years of experience.

A second approach is to take special advanced training. This might mean taking a good photography course coupled with from two to four years of general instruction in junior college or college. You might work for the school paper or get a part-time job with a local weekly or daily. You might even take a summer internship position with a newspaper to further your education. At the end of this time, if you can supply adequate proof of competency, larger city papers will be interested in your services.

The third approach is to get a job in a related field, such as public relations photography for a hospital or business, or to join the military as a photography specialist. In both instances, a large variety of assignments will be handed to you, and you gain experience behind the camera and learn publication techniques. The switch is then easy to make.

The largest city newspapers and the wire services such as the Associated Press and United Press International are the most selective in their hiring. They normally want to see experience on smaller daily papers as part of your background. However, it does no harm to apply for such work when you are first looking for a job on the chance that you will be considered. Many times they will give a promising individual a chance.

Newspaper jobs are not obtained through the personnel office, though the paperwork is done there. Contact the managing editor when looking for work. That person may do the hiring, or you may be referred to the photography editor. These individuals will make the final decision concerning such a creative, skilled position. Personnel applications are a waste of time until you are asked to fill one out by the editors.

Magazines hire in a similar manner as newspapers, though they are more selective about the work they want to see. *Time* and *Newsweek* are among the publications that use general assignment photographers. However, most publications are specialized. They cover sports, wildlife, or some other area of specific interest. They want to see your pictures only if they relate to their editorial needs. You are not required to have covered major events, but your work should relate to their ends in some way. Any type of sports work is fine for a sports publication, for instance. Wildlife photos are needed for a wildlife magazine, though zoo pictures will be spotted and rejected since the animals are captive, not recorded in the wild.

There are two ways to break into the magazine field. One is to apply for a job in the same way you would with a newspaper. This can be an expensive gamble unless you live in a major publishing center such as New York, or can afford to spend a couple of weeks making appointments to see editors.

An alternative is to start by freelancing for the publication. Put together both single images and photo stories, then offer them through the mail on a freelance basis. You query the

publication, explaining what you have and offering to send the work on speculation. A self-addressed stamped envelope (SASE) is sent with the query. A larger SASE is sent when you mail the actual photos so that they can be returned if your work is inappropriate at the moment. A publication cannot afford to pay for the postage to return your work. Providing an adequately large envelope for the return, addressed and properly stamped, is essential.

The best two photography market guides are the annually updated *Writer's Market* and *Photographer's Market,* both published by Writer's Digest Books. *Where and How to Sell Your Photographs,* published by Amphoto, has excellent general information about freelancing. However, because it is not updated annually, the market list of an older edition is often of limited use. Your library will also have the *Editor and Publisher* newspaper and syndicate annuals listing every newspaper and newspaper syndicate in the country. The newspaper annual is a massive book published around July or August of each year. The syndicate annual is magazine size and inserted in the weekly *Editor and Publisher* magazine sometime in July, then retained by most library reference divisions. Both will give you ideas for marketing.

Once some of your material has been published, it is often possible to shift to a full-time job with the publication for which you have worked. You should talk with the managing editor at that time, your clippings serving as proof of your skills. You will be perceived as understanding the publication's market needs, and other background details related to your training will be secondary.

Regardless of whether you use a photography course, college training, or self-training to learn photojournalism, experience is the key to entering this career field. You should attempt to freelance at every opportunity you can find, working with both available light and flash. Most high schools will welcome your presence at sporting events and stage productions. You may be able to work for local arenas and community center buildings that handle occasional publicity photos

taken during the time a group is appearing. You should also talk to various local organizations about recording the events they hold so that you can practice working under pressure. Having contact sheets on file from such activities will increase your ability to demonstrate versatility.

Some police departments have ride-along programs in which you can accompany a patrol car. You may be allowed to take a camera, provided you accept whatever rules are established by both the department and the officers at the time you encounter a visually interesting situation. Occasionally a police officer enters an area where a crowd is hot, angry, and perhaps under the influence of alcohol. An arrest has to be made and the scene is tense. A skilled officer can get in and out without serious risk and without having to call for extra units. If you are there and you are asked to remain inside the car with your camera down on the floor, do so. Showing a camera or using a flash may result in a tense but minor situation degenerating into a riot. You could be the cause of needless, avoidable violence and your reputation could be ruined. Even worse, you may put men and women into life-threatening situations that otherwise would not exist.

When you take color photographs for samples, try to use transparency film as often as possible. Magazines want to publish from slides and you can make prints from your slides for portfolio purposes. More important to the editor, a slide offers no latitude for error. An incorrect exposure is immediately obvious. Showing a selection of properly exposed slides is proof of technical knowledge that is essential for gaining a job.

Only the smallest newspapers might require you to own your own camera equipment. Normally a newspaper will supply you with everything you need or an allowance to buy certain basics. Newspapers usually standardize on a specific system and own unusual accessories for occasional use. For example, one paper may use only Leicas, issuing each photographer a Leica M-4 and lenses that range from 28mm through 135mm. Additional bodies, motor drives, extremely wide-angle

and telephoto lenses, plus reflex housing, are all kept by the paper to be checked out by the photographers as needed. Another paper might utilize the Nikon system. They will all be likely to have special-purpose cameras for studio use at the paper's offices. These might include roll film cameras or view camera equipment for architecture, illustration, and special copying needs.

When you go to work for a photography studio, you will be expected to operate every piece of equipment on hand. You will have to understand the multiple lighting system used and be able to work with a wide variety of cameras right at the start. Newspapers and magazines do not have the same expectations. You will be required to handle the systems they use on a regular basis, but these are almost always 35mm and quite similar to what you now use. You will learn everything else on the job.

Overseas assignments usually are dependent on your work record within the United States. Major wire services and large city newspapers have photographers working in Europe and Asia on assignment. Some are stringers, natives of foreign countries who sell to publications in the United States when they have appropriate material. Others are staff members who have applied for the position after establishing a solid reputation in the United States.

There are also organizations such as Magnum, which are cooperatives of photographers who handle stories for magazines, work for book publishers, produce record covers, do annual reports, and handle other such work. Photojournalism is a large percentage of their work. However, membership in such groups is limited and the requirements are similar to those for newspapers. The members usually must establish a solid reputation, since the group is supported by a percentage of each member's income. Members must be self-motivated and able to generate business as well as to work effectively with their cameras. More critical, perhaps, is the fact that members must supply their own equipment. This takes a capital outlay many skilled beginners cannot afford, so most

members come from other fields where they have established themselves.

There is no way to predict the opportunities for creative growth based on the size of the newspaper. Working for *The New York Times* has been the ultimate achievement for newspaper writers, but there are papers in small communities that are famous for effective use of photographs. Such papers actually have a better reputation among photographers than do many of the major city dailies. Thus, your location in a small town may be an advantage rather than a liability in developing a photojournalism career.

All the schools listed later in this book will provide backgrounds that are of value for photojournalism. Remember that you need to combine photography training with as broad a general education as possible in order to be of the greatest value to a paper or magazine.

5

Scientific Photography

No matter which scientific field you consider—medicine, manufacturing, aerospace design, botany, or anything else—it will have a need for photographic records of its activities. Sometimes this is a critical factor in diagnosis, such as when photographs of the retina of the eye reveal subtle color changes over time that indicate problems the doctor might otherwise miss. Other times the record is meant as a training aid. Still other times the photographs are additional pieces of evidence in a puzzle that might lead to a new invention, medical discovery, or just a new understanding of human existence.

There are few actual jobs for a photographer who wants to enter the scientific field. Instead, the jobs are for people trained in science who are also skilled with a camera. For example, a research laboratory will hire a trained technician who also has camera skills. The person will spend most of the day recording through a microscope and using cameras for various

scientific instruments. The job is basically that of a photographer. However, the person must also understand the images he or she is viewing. This requires a scientific background. Photography is an essential skill but a secondary one.

The single common exception is in the field of hospital photography. Hospital photographers fall into several categories, depending on the size of the medical complex, the amount of research being done, and what are perceived to be the photographic needs. Some photographers are hired for all of the hospital's needs. Others are hired by a specific department and must be scientifically knowledgeable.

In small communities a hospital is likely to have neither research staff nor a full-time photographer. The hospital is basically an elaborate emergency service handling accident victims, routine surgery, and similar care. The staff is frequently excellent, but they are not equipped for specialized services that are seldom in demand. Such unusual cases are sent to the nearest big city medical center, where ultrasophisticated testing equipment, special intensive care treatment, and an unusually well-trained staff may be found.

The small-town hospital has three photographic needs. One is the photography of new infants, which might be handled by a nurse trained to do this when the budget is tight. The pictures are intended both for identification records and for sale to the families.

The second need is for general photography related to the hospital. There will be photographs of the building when changes are made or when the facility needs publicity. Standard annual-report-type images will be made of the staff at work. Pictures will be taken at meetings, dinners, and awards banquets relating to the staff. Whatever arises that should be photographed will be handled by an outside photographer.

The third need is for occasional pictures of surgical procedures and other technical work. These are taken when a doctor wants to use them for on-the-job training purposes or to illustrate a lecture. They are usually not as critical as photos taken in research hospitals, but the sterile conditions

and the precautions for protecting the patient from infection are the same.

Larger hospitals often have a budget that allows for a staff photographer. This person works primarily through the public relations department and does the same type of work as the small-town hospital photographer. There is just more of it to do. Thus the job becomes full-time and not part-time.

Extremely large hospitals may add videotape production to the photographer's duties. Videotape presentations are made both for the staff and for closed circuit television programming. Such programs are used for ongoing education of the hospital patients. Each tape usually relates to a specific topic of concern, such as the fight against arthritis, ways to recover from a heart attack, and so forth. These can be viewed by interested hospital patients.

The training scientific photographers need usually comes after they have a solid understanding of their field. Any individuals interested in this area would do well to talk to potential employers to learn what sort of scientific training, engineering skills, knowledge of biology, or other education they should have. Then they should study that field, often by taking a two-year training program rather than getting a four-year degree, to qualify. The photographic training would be an adjunct and can often be learned through home study. It is the combination of skills, with the emphasis on the scientific, that ensures the jobs in this field.

The need for scientific background is evident in some of the publications aimed for photographers in this field. *Functional Photography* magazine, for example, assumes that the readers are not particularly knowledgeable in the broad area of photography. Instead, they are perceived to be scientists and engineers who use photography for a large portion of their work.

Once on the job, there are numerous training programs to advance your knowledge of photography. Eastman Kodak offers some of these. Others may come from the manufacturers of highly specialized instruments such as electron microscopes.

Still other programs are taught in-house by universities, staff experts sent from corporate headquarters, and similar individuals.

The scientific photographer must have a love of science and the desire to handle extremely detailed work. He or she must be trained in the field in which the photography will be used, the exception being the hospital work mentioned earlier. Such specialized schools are beyond the scope of this book, but information can easily be obtained from nearby colleges and by talking with potential employers. Potential employers can tell you what type of background you will need and which training schools seem to produce graduates who perform effectively on the job.

Photographic training can come from almost any source. Emphasis should be placed on laboratory work, especially color and black-and-white processing and printing. These skills will usually be required. If you can gain a working knowledge of videotape as well, this will also add to your desirability. Usually photographers who study at junior colleges and universities can cross over part of their training, working with the television or audiovisual section for basic video camera technique instruction. Some schools offering such courses are listed later in this book.

6

Camera Repair

Generally, two types of individuals are interested in photography careers. One type cannot wait to get hold of a camera and go out to take pictures. This person might like to focus on people or places, buildings or machinery. Whatever the case, he or she likes to take picture after picture, cursing any breakdowns in equipment that might cause even a day's delay before the next outing.

The second type enjoys photography as well. However, this person is a tinkerer, someone who is intrigued by the workings of cameras. He or she is happiest with the mechanical and electronic aspects of the camera, playing with the components and fine-tuning the instrument. This photographer will restore the camera to its optimum technical capability whenever it falls short of its manufactured expectations. It is this type of individual who may be interested in a career in camera repair, an essential field that is a highly desirable way to earn a living.

It might seem that there is a consistency in the demands camera repair personnel place on new employees. The reality is quite different. The training being sought, the expectations, and the backgrounds of the individuals vary to a surprising degree.

For example, Marty Forscher is the founder and owner of Professional Camera Repair in New York City. There are undoubtedly other firms as creative and skilled. However, it is unlikely that anyone in the country is any better than Forscher and his staff. Their clients, ranging from the space program to professionals working around the world to serious amateurs, swear by them. Forscher and his staff customize cameras, adapt radically different pieces of equipment in order to make them interchangeable, build equipment from scratch, and design special tools no one has seen before. Motor drives and rapid winders are taken for granted. Forscher created what is believed to be the first rapid winder, scratch built from his own design, for a professional in need of a way to advance the film more quickly. Nothing like it was known to exist and no one realized its potential. A customer came to Marty with a problem and he developed the perfect solution.

"The kind of repairman who interests me is the person who might have built models as a hobby when growing up," said Forscher, speaking of his concerns when hiring a new employee. "But instead of building from a kit, he took a tin can, a shears, and a soldering iron, and built a model car."

Forscher's business has made its reputation on innovation as well as on top-quality repair. He began his business shortly after World War II ended, at a time when flash synchronization had yet to be developed, shutters were mechanical, and exposure meters were ineffective in low light. Today he deals with extremely sophisticated electronic equipment because of the way cameras have changed. He still sees the mechanical equipment and companies such as Leica continue to make a mechanical line for professionals, which he maintains. But the bulk of equipment entering the shop is electronic.

"I look for new technicians who have had an introduction to electronic skills," said Forscher. "Maybe they went to a

vocational high school where they got hands-on experience tracing circuits and in basic computer logic. I want them to know proper soldering because that's critical in this business. It's not difficult, but soldering's not taught very well. It's an important procedure for circuitry.

"We can teach someone the mechanical skills needed. We can teach them the integration of mechanics and electronics. But they have to have that electronic understanding."

Forscher said that someone interested in camera repair should have training in electronics, which can come from a wide variety of courses. It does not have to be from a repair school or special program, though he did mention that the Bergen County Junior College in Paramus, New Jersey, is one whose graduates he has come to respect. He also mentioned people who have been trained in allied fields such as by IBM and Control Data. Computer industry schools have excellent educational programs providing electronics backgrounds that are adaptable to camera work.

In Forscher's view, the one problem that many otherwise competent camera repair people have is in understanding the field as a business. "The relative cost of cameras is quite low and the cost of service has risen recently," he said. "If a camera takes three hours to repair, the cost for the repair is going to be quite high. We need people who can turn out quality work rapidly. We demand a combination of skill and productivity. We can't sacrifice either one. Our people have to work effectively, accurately, and rapidly enough to keep the charge realistic. When someone does magnificent work but can't maintain a strong production rate, we have to let him go."

Phoenix Camera Repair in Phoenix, Arizona, is more typical of a quality repair department in that maintenance, not radical adaptations, is the primary function of the staff. However, the demand for a background in electronics remains critical.

"One reason some people don't make it is that they lack the patience for it," said Ernie Weegen, president of Phoenix Camera Repair. "They have to be able to sit at a bench,

working with small parts all day. It can be frustrating. It takes a very patient individual."

One of the problems Weegen mentioned is trying to start into business on your own. The cost of tools can be much higher than admitted by some camera repair schools. A single tester can start at $5,000 and rise rapidly from there. Supplementary training seminars require at least an eight-week commitment every two years. An individual working alone after graduation can't afford this type of cash outlay. Either the repair shop must offer far fewer services than desired or expensive testing equipment must be forsaken, with the subsequent risk of less dependable results.

Larger repair shops can have specialists, too. Michael Lowe of the Rocky Mountain Camera Repair wrote, "We look for former experience in camera repair or training in mechanical ability or hobbies in model planes or such in using your hands. We do take students from the local camera repair school but prefer to get them before they have had any training.

"We use factory training courses on videotape or slides with tapes. Trainees are started on less expensive cameras and as they progress they move on to the more difficult cameras or projectors.

"We send two or three technicians a year to factories for training on the new models as they are released by the manufacturer.

"A trainee is started at the minimum wage, his pay rises, and he will advance according to his production. A technician is expected to produce 3½ times his salary at the end of the training period.

"Our technicians train and specialize in certain brands and models; we find our production is better under this type of system. Several of our technicians continue training by taking correspondence courses in electronics"

There is actually just one resident school in camera repair that is well known. This is National Camera in Englewood, Colorado, and the reaction to it has been mixed. Michael

Lowe's letter to me stressed that he likes to teach repair in-house. Other repair personnel want the candidate to have formal training in a junior college or other program. Still other repair people stress the knowledge of electronics, though such training is given by National.

The one consistent requirement for a career in camera repair is the enjoyment of detail work. The person must learn to handle small complex items quickly and accurately. Production rate is a very close second to skill in priorities. A flawless technician who cannot work quickly cannot retain a job. Quality is essential, but it is quality plus speed, not quality alone.

The second requirement is an interest and background in basic electronics. This is vital with modern cameras and more difficult to teach in-house than mechanical skills related to older equipment.

If you have patience, enjoy working with detail, can function quickly without sacrificing quality, and understand basic electronics, this may be the field for you. The salaries are equivalent to those earned by typical studio photographers, and the profession, for those who enjoy it, is every bit as challenging as being behind the camera.

7

Television Careers

Television is one of the most important influences in modern American life. It has given us instant access to news and entertainment occurring throughout the world. Satellite transmissions allow us to watch an opera in Sydney, Australia, at the same time that the audience is seated in the house. We can view a riot in Japan the moment the police are trying to bring the crowd under control. And we can watch a baseball game from a Houston hotel room at the same time the fans are sitting in the bleachers in New York.

Children raised on television are more sophisticated than generations raised without the medium. They have knowledge of the world around them that was once possible only through extensive travel and reading. We not only hear about the triumphs and disasters in the world when they occur; we often see them unfolding before our eyes. Yet we sometimes forget that the event we are witnessing is the result of the skilled work of a faceless photographer.

Television has undergone a number of evolutionary stages over the years in terms of photographic careers. There was a time when motion picture film was the primary tool of the medium. Photographers armed with key-wound and battery-operated 16mm cameras took footage of fires, robberies in progress, and all the other news of the day. A reporter often did double duty behind a portable camera, silently recording an event that would be reported with a voice-over back at the station. Sound equipment was also used, but this was extremely bulky and was saved for major stories.

Next came the development of Super-8 equipment, and film still predominated. The film had been refined to the point at which it did come across well on the smaller television sets, though it could not be placed effectively on an extremely large screen. It was cheaper than 16mm and easier to operate. Special units with 200-foot reels also made longer stories possible. Sound units were more compact and the total effect added to the immediacy of the news for those stations that switched to Super-8.

Now there has been another change, this time to video cameras and videotape. The equipment is highly portable and handles differently from film in terms of editing potential and ease of coverage. However, the concept behind telling a news story with movement remains the same as before, and this can be an advantage for you.

It is doubtful that anyone in the country interested in a career as a television camera operator has similar home equipment. There was a time when many individuals owned 16mm cameras and still others had reasonably sophisticated Super-8 equipment. However, the home videotape recorders are not the same as the equipment the television stations use.

Television stations have a hierarchy of jobs related to the operation of cameras. The majority of television executives like to think that someone has paid his or her dues by working up from the tiniest of markets. This gives the executives a large body of work to review to see how someone has handled stories under pressure. However, this also ex-

cludes young individuals with tremendous talent and ability who may be ready to start at the top. Thus, some station executives are willing to consider inexperienced but creative personnel, though such executives are in the minority.

The best way to break into television as a career is to obtain basic training in the type of video equipment used in the industry. This can be done in several different ways. One approach is to attend a good television training program at a college or junior college. A few broadcasting schools around the country also offer such training. The only drawback is that many are staffed by relatively inexperienced personnel and others have limited, outdated equipment. Courses on the college or junior college level are preferable.

Another way to obtain training is actually to work in the field at a small station. Many communities have local outlets where enthusiastic untrained individuals are hired out of high school to handle the cameras. Sometimes they receive on-the-job training, working with more experienced personnel. Other times they act as gofers, doing anything that needs to be done. They will carry the cameras to the location, set up lights, and do all the tasks besides handling the cameras. Their training in camera operation has to come by asking questions after hours, a rather discouraging way to learn. There is no way to predict which approach a station will use until you talk with the personnel.

The problem with on-the-job education without special study in advance lies in the fact that there are two types of television camera operators in most markets. One person works in the studio, recording live shows, commercials, and other projects involving a prebuilt set and limited movement. This person must work well with the director and use an artistic touch when handling the camera, but the total skills required are relatively limited. This is not a pressure-type job in which the individual must be able to handle the unpredictable. Thus, the pay is relatively low and the job is not nearly as much fun as work that involves location photography.

The second type of camera operator goes where the action is

happening. This person covers the hard news, sports, and other events that take place, often without warning. The individual must be so familiar with the equipment that the photography becomes second nature. Action is followed smoothly; a variety of long, medium, and close shots is used; and the viewing audience never realizes the intense pressure under which the work was recorded.

The difficulty in spot news coverage is obvious to sports fans. If you have ever gone to a football game, baseball game, or similar sporting event, you may have been fooled many times by the action on the field. A faked pass, a pitcher suddenly throwing to a baseman rather than to the batter in order to strike out someone stealing a base, and similar action may have surprised you. You were looking one way, certain you were seeing the primary action, only to find that everything exciting was taking place in a different spot. The television camera operator cannot be fooled in this way or the home viewing audience will be angered. The audience wants to see exactly what is happening and relies on the photographer to show it.

The person who works in the field must be able to show skill in handling the unknown. He or she is also in an unusual position of often being responsible for the equipment. The photographer is expected to understand enough about the cameras to be able to handle minor repairs in the field. Only the larger stations are likely to send a trained electronics repair person into the field with the photography crew to handle breakdowns. Even when this is done, it is usually for major events at which coverage is essential and damage is likely. At other times the photographer is expected to be master of the equipment. It is difficult at best and does require a basic understanding of electronics, something that is standard in junior college and university television courses.

To give you an idea of what is expected, the following is a job description for a news photographer/editor for KHOU television in Houston. This is a major broadcasting area and at the time of this writing, KHOU was a CBS affiliate.

The education and experience requirements are "High
school diploma required; college degree preferred. Experience
in news photography required; familiarity with electronic
news gathering equipment (minicam) strongly preferred—
although not required if applicant does have experience in
shooting/editing 16mm motion picture film."

The statement about working with 16mm is consistent
throughout the country. Most stations will train you in the
technical side of video camera work. The ability to tell a story
effectively under deadline pressure has nothing to do with the
type of equipment used. The station managers understand
that if someone has worked well with film, he or she will also
work well with videotape once the video camera is understood.

In terms of duties and responsibilities, the news photog-
rapher/editor working for KHOU included: "Records on
minicam videotape and/or film events for news and other
station programs. Operates equipment to provide the most
imaginative and highest quality visuals possible. Is responsi-
ble for proper operation of and care for photographic equip-
ment. Drives news vehicles and is responsible for safe opera-
tion and maintenance of vehicles personally assigned.
Maintains records of videotape/film usage.

"Job entails regular, weekend and odd hours, depending on
requirements of shift—which may change frequently. Reports
to the News Director, but receives work assignments from the
Assignment Editor. Develops ideas for stories. Ability to take
direction and to communicate well with other staff members is
absolute necessity."

Notice that the care of the equipment is mentioned in the
job description of the photographer working on location.
This is quite different from the job of camera operator inside
the studio, a job for which a high school diploma was the
only requirement at the time I contacted the station. That
description read: "Must be familiar with all phases of televi-
sion camera operation in studio or on remote location. Solid
background in basic set production, lighting, staging, etc.,
highly desirable. *MUST* have a feel for esthetics and mechan-

ics of camera operation. Operates cameras and other studio equipment under the supervision of an assigned producer/director or the Production Manager. Must be able to master operation of Chiron III-B Character Generator within ninety days of employment."

A person who enters work in television by training for the studio camera position rather than first getting a broader background may find advancement difficult. Many stations have ratings that are affected by the popularity of their news and other location work. If a camera operator fails on location, the station may lose viewers and advertising revenue. No one is going to be likely to risk sending an unproven individual from within the studio to a location setting because failure is too expensive. Thus going from a studio position learned strictly on the job to news camera operation may not be possible with a particular station.

The director of operations for WCPO television in Cincinnati, a Scripps-Howard Broadcasting Company, wrote of location photography positions: "We seek background that indicates experience on a practical level in the news and production area. A production photographer must exhibit a reel that indicates a production 'eye,' which is difficult to define but which encompasses the area of sensitivity, composition, and lighting technique. In the news area, we seek backgrounds that indicate the basic facility in shooting and equipment handling and video work while still retaining all the elements such as wide, medium, and tight shots; cutaways and reverses; along with rapid edit of the material. Job experience at a television broadcast facility or some film production house is usually required. In general we have found the radio and television school ineffective in preparing photographers."

The executive news director of KFMB-TV in San Diego commented, "When we're looking for someone, we look first for that person who has a fair amount of experience in shooting/editing both film and videotape. Most often, that experience has been gained at another television station.

"Beyond that, we want someone with a little creativity and the willingness to work long and hard. Once found, we have a good TV news photographer, one who will get plenty of training by being on the job five days a week."

A somewhat different view came from the production manager of WSBK-TV in Boston, Masschusetts, This is an independent station that utilizes film as well as video. The production manager commented, "What I look for in a cinematographer/photographer is a well-rounded individual with a great deal of self-motivation. I put a great deal of weight on experience; I don't have the time to train anyone. The person must be experienced in all phases of 16mm film and have done still (35mm) and darkroom work.

"WSBK-TV is an independent, and the more people we get here who can wear more than one hat, the better. Our current cinematographer/photographer is a graduate of the school of photography at State University of New York. He has done several documentaries, by himself and with others. He is the kind of person who continually strives for the best and gets it.

"Our cinematographer's growth is limited only by his own desires. Yes, he works under adverse conditions sometimes, but I feel this not only tests his skills, but sharpens his creativity."

At KG-TV in San Diego, a McGraw-Hill Broadcasting Company, the assistant news director said, "Cameramen for studio work are generally 'engineers' in most local television stations . . . most with little or no training, who learn at the respective television stations they work for.

"News cameramen of the past were largely still photographers who made the transition into news photography when the business was new. Today's photographers come from schools such as the School of Photography in Santa Barbara, California . . . where cinematography is a major.

"But because the trend is now away from film in television and toward electronic news-gathering (ENG) cameras . . . the transition from film to ENG is being learned by film cameramen at the stations they work for. There is no ENG school that we are aware of.

"As for background . . . we obviously are searching for men and women with *two* major areas of background and interest . . . the first now being that they have *journalism* majors, the second a strong interest in cinematography."

At the very top of the television business for photographers are jobs with the networks. WCBS-TV in New York is the CBS network's flagship station. This is the ultimate career spot in terms of pay, challenge, and respect. When I contacted the director of technical operations, I was told, "WCBS-TV has recently undergone a conversion of its news-gathering operations from film to an all-electronic operation. The hiring of qualified ENG technicians was crucial to the success of this conversion.

"Emphasis was placed on the hiring of competent technicians rather than on photographers. Photojournalistic skills are certainly essential to convey interesting and stimulating information to the viewer; however, I have found that 'photographers' generally do not possess the necessary technical skills to ensure that the story will be successfully videotaped or microwaved back to the newsroom.

"Whenever hiring new employees in this field, I expect people to be well versed in handling audio and video recording as well as possessing photographic skills. In addition, either a maintenance background or editing ability is a necessary complement.

"The majority of technicians hired by this station during the past year have between five and ten years of news-gathering experience in smaller market stations throughout the country. This has given them opportunities to develop photographic and editing skills. Many of them have also operated as 'one-man bands' in the gathering of news, thereby ensuring familiarity with camera and VTR. Then upon returning to their station, they also edit the piece for the evening news broadcast. That experience has proven to be invaluable to us in developing a versatile staff of technicians able to operate effectively as news crews, tape editors, and assisting in maintenance areas. We do not hire graduates of

any particular training school. Furthermore, we do not train people; rather, it is expected that they will come to us with the necessary skills. The academic credentials of our technicians are generally BSs and MAs in fine arts or communications with a major in television production.

"There seems to be a widespread feeling among many applicants that the possession of a First Class FCC license makes them more valuable or enhances job prospects. I would like to dispel that notion. At this station that is not the case unless the license is supported by practical maintenance experience. I would prefer to see people spend a year or so gaining experience on the maintenance of VTRs and cameras or attending a community college specializing in electronics technology. This would give them the necessary technical background to complement their photojournalistic skills."

Now that you have seen a sampling of responses from stations around the country, what is the best way to prepare yourself for a career in television camera work? My feeling, after talking with representatives from both small isolated stations and major market areas, is that training on the junior college or college level is essential. You should study television broadcasting and be certain to get hands-on experience with the equipment. You might also want to obtain training in electronics and cinematography as additions, though these are not essential. Courses in basic journalism and broadcast journalism will be extremely helpful because you will better understand your role in this industry.

Next get a job with a smaller station where you will be able to handle as many assignments as possible. Hopefully this will include videotape, but, even if you choose a station that still uses film, use of the camera equipment is the important factor.

Once you feel you are ready to move on, you will need to prepare a demonstration tape. (Film is all right to use if you do not have access to tape equipment. Given a choice, tape is preferable.) Eventually you will be using only electronics and

your mastery of the technical side should be demonstrated whenever possible.

The demonstration tape, usually no more than ten minutes long, will show your versatility. It should show how you cover a breaking story as well as how you record a day when nothing is happening in your town. If the community in which you work is small, you may not encounter any hard news that requires pressure work. However, station managers have told me that this gap can be filled with high school or even junior high school sporting events. Photograph a football game or other action sport that is equally unpredictable. This is little different from spot news and shows your skills under difficult conditions.

A station will usually want to see versatility in your background, and this can take three to four years of experience. Try to handle as many jobs related to camera work and maintenance as you can. Also try to keep up with the latest developments in the field, even if they don't relate to your job. Read trade journals for the video industry so you can learn what innovations are coming. Take advanced training when necessary and available so that your skill always exceeds your present responsibilities. Such action is extremely impressive to potential employers because you will be able to help smooth transitions to more sophisticated equipment.

Remember that television work is a constantly changing field. Today's state-of-the-art camera will be obsolete tomorrow. The farther you are ahead of presently owned equipment—at least understanding the concepts behind some of the new innovations, the more valuable you are to a potential employer.

Salaries for television photographers in the major markets are quite high. Similar incomes can be earned by photographers working for audiovisual firms, but they are usually 30 percent to 50 percent higher than will be received by many still photographers who own small studios.

One word of warning while you advance: Each time you

consider moving to a new station, carefully weigh the require-
ments against your current lifestyle. A news photographer
who is accustomed to roaming the streets of the same city, day
after day, in moving to a larger market, might suddenly be
called on to travel abroad at a moment's notice. This can be
disruptive to your personal life, at best. If you are not
prepared for the change, you can hurt or destroy present
relationships. This is only avoided through advanced plan-
ning with everyone who may be affected.

8

Audiovisual Photography

Audiovisual photography might be considered a hybrid of commercial photography and television work. Photographers specializing in this area are often versed in a broad range of disciplines. They understand videotape as thoroughly as television production crews, though some studios use the smaller amateur sizes such as VHS and Beta, which are compatible with home units. They will also understand film, sound equipment, and still photography. The end result is often similar from client to client, but the means to this end will vary greatly.

For example, suppose a new luxury hotel is being built in your neighborhood. You work with a firm specializing in audiovisual work. How will this new construction affect you?

The first contact with the project might relate to special promotions desired by the builder. Still photographs will be taken in the normal way. However, additional images will be needed for a slide or movie presentation relating to the

company's production methods. This will be done as a means of generating new business for the construction company. Probably a concrete post will be sunk in a location providing a good view of the site. The concrete will be fitted with a device for holding still and/or motion cameras so pictures can be taken from exactly the same position each day. This allows for time lapse photography showing the construction and will be supplemented by handwork on other areas of the site. These pictures will be shown at conventions, to other possible firms interested in construction, and anywhere else they might generate business.

Your next client would be the owner of the hotel when it is completed. A film or series of stills designed for reproduction on television will be made for advertising. Specific stills will be taken separately for brochures, though the latter might be handled by a commercial studio rather than the audiovisual firm.

Now the staff has to be trained, and what better way to do it than with a film strip, videotape, or movie that can be shown to each new person hired. One strip will show new cleaning personnel how to clean a room properly, thoroughly, and efficiently. A second strip, tape, or movie will relate to structural maintenance. A third presentation might relate to handling check-in, reservations, and similar duties. Such an approach standardizes training and ensures that at least minimum expectations of the guests will be met.

A third employer might be a private business that wants to prepare a documentary for television or similar use. This documentary might be on the changing business face of the community, with the new hotel reflecting part of this change.

Numerous positions are available with audiovisual firms, but they vary both from community to community and from firm to firm. Some are totally in-house operations. Others are cooperatives of writers and artists who contract with area photographers, sound specialists, and video equipment operators to handle the actual work. Instead of paying salaries to a large number of employees, the companies pay specialists by the

job, letting them fend for their living elsewhere. The people used may work for a local studio, be employed by the area television station, or have some similar related job.

The best way to find out what is desired is to talk with firms in the area in which you want to work. Learn what their needs are and whether or not you are interested in taking the positions open. Some may involve only still camera work and others may expect you to know everything from lighting to 35mm motion picture film to videotape. You should learn which skills are needed, how your skills relate to them, and what training you might need.

There are several types of training you should get, but television training, described in the previous chapter, is an important area for study. You should also learn sound recording and basic still camera technique. Most colleges and junior colleges provide this kind of background.

Still camera and movie camera skills are essential. However, these can be fairly basic. Most still work for audiovisual use will involve planning for television that stresses the horizontal image. This is no problem to learn and you will not be expected to have this type of training in advance.

It is best to learn still photography in a school for audiovisual work because you will need to be exposed to a wide variety of cameras. One audiovisual firm told me that they expect a new employee to have hands-on familiarity with 4-by-5 cameras, roll film single-lens reflexes, movie cameras, special macro equipment, and the like. Self-taught photographers often have an excellent ability to see creatively, plus high motivation, but limited technical experience on which to rely. Thus, most firms that hire staff photographers do want to see professional schooling, a different situation from that which exists for commercial studios.

9

Custom Processing
Laboratory Work

Few photography careers result in greater nervousness and, perhaps, greater pride than earning a living processing and printing the pictures others have taken. The amateur photographer sees photographs as babies, the special creations of memorable days. The professional photographer relies on pictures to provide his or her livelihood. Both types of individuals see the darkroom technician as the key to their happiness or the cause of their misery.

Photographic processing and printing have changed radically in recent years. The major labs are automated and computerized. Photographs are mass-printed and everything is done by machine. The machines can provide a finished print almost as perfect as a custom print made by hand a few years ago, though the consistency of quality depends on the skill of the operator.

A second type of custom processing laboratory may also be largely automated, but it also has skilled technicians who

produce black-and-white and/or color prints by hand. These individuals will process film exposed at higher than normal ASA ratings. They will use special developers as requested. They will carefully retouch negatives and prints, dodge and burn in detals in black-and-white prints, and otherwise create final work that brings out all the beauty possible from a negative or slide. Their quality is consistent and they can be relied on to meet deadlines.

Some custom labs go so far as to perform special services for their customers. For example, Modernage is one of the largest photofinishing operations in Manhattan. It is primarily a custom service and it is used by many professional photographers and publishers in New York. Periodically, when I have to rush assignment for a magazine based in Manhattan, I use express mail for overnight delivery of my film to Modernage. It will be processed, quickly screened, and shipped to the magazine. When I work with color slides, the lab will quickly edit any serious mistakes at my request, thus saving my reputation. There is a charge for the special messenger service and unusual handling, but I know I can rely on the lab to meet my deadlines. Since I frequently send my work from the West, this assurance of quality handling is essential.

Other custom labs may not go quite so far out of their way, but they all are selling speed with high quality. In this profession, like that of the camera repair person, you must do top work but at reasonably rapid speed in order to keep costs as low as realistically possible.

The training necessary for custom lab work varies. Harry Amdur, president of Modernage, commented on how he views the career field. He said, "The field of photo technicians, that is to say technicians who work in a lab, has been the fastest growing in the photo industry. One has to look only through the want ads and count how many of them ask for photographers and how many for lab technicians. The numbers are astounding.

"In hiring prospective employees we like to find individuals who show a burning interest in lab procedures and intend to

pursue it as a career. We want someone who is not completely green but has some knowledge of darkroom procedures, whether through fooling around at home or in high school.

"There is really no one source that we have found to be a good source for aspiring interns, although the High School for Art and Design here in New York seems to turn out the most qualified candidates.

"When such an individual is hired he is put next to one of the older technicians so he or she can see how things are done. Advancement depends on the individual's progression and initiative. All our supervisors came through this progression and thus are fully competent in discussing jobs with clients. Moneywise, there are many technicians earning more money than a photographer, with the added plus of job security. Your question of what schools one might refer someone to is a difficult one since all schools with photographic departments are good, but it is the competence of the individual instructor that sets one school apart from another. One should try to pick a school with good photo equipment in its department and then check the background of the instructor."

A number of schools around the country offer specific courses for people interested in careers in darkroom work. For example, the Randolph Technical College in Asheboro, North Carolina, has such a course of study. You can take either an Associate in Applied Science degree providing training as a photographer with emphasis on studio operation or you can study for darkroom work. To give you an idea of the scope of their program, the first quarter courses include "Fundamentals of Photography," "Photochemistry," "Process Control," "Fundamentals of Electricity," and "Business Math."

During the next three quarters of study, all of which are required, a student covers automated and custom finishing, retouching, business skills, and communication. There are also two advanced quarters, which can be taken as options. These stress management and help someone working in a lab eventually to handle all phases of running it.

If your interest is in photofinishing rather than picture

taking, you must obtain training in which you can work with processing and printing equipment. You will want to handle color, black and white, and both automated units and custom work. Most schools offering photography courses with emphasis on studio work rather than fine arts will have such facilities. Many are listed in this book.

When you consider a school, learn what type of lab facilities it has. Then find out about the background of the staff. Have they handled professional photofinishing in a custom lab? In other words, what has been their practical experience in this field?

An alternative is to apprentice with a large lab where you will be able to learn all facets of the work. This is a field where apprentice training is still possible. If you can show an interest in this field and, hopefully, have done some work at home or in school, you will often be given a chance. You will probably start by doing routine chores in the automated area, then advance as you prove yourself. However, producing under pressure in the working lab is the best way to gain skills that will be salable anywhere in the country.

The income of a photofinisher is often as high as that of the photographer in a smaller studio operation, once you become skilled in custom work. However, you can also work into management and field sales for larger companies. You might also enter the field of technical representative for one of the firms that manufactures or sells custom supplies for professional labs. Thus it can be a stepping stone for all manner of related careers where the income potential is limited only by your sales abilities.

A WORD ABOUT MOTION PICTURES

You may have noticed that there is no separate section covering a career in motion picture photography. This is because such careers are extremely limited today. Videotape

has taken over the bulk of the television industry, the few stations still using film having made plans to switch to tape. The Hollywood motion picture industry requires earning union membership and the chances are expected to be minimal over the next few years. So it is primarily in the audiovisual field that such skills are desired as part of your overall competency as a photographer.

If you remain interested in being a motion picture photographer, be sure to select a school which provides a broader range of training. Motion picture work should be combined with training in video and still work. This makes you most valuable in this field and ensures your finding a job. Such knowledge is also useful in scientific, medical, and industrial areas. However, audiovisual will be the primary field for potential employment.

Once you have training and experience in the audiovisual field and you still want to see what opportunities may be developing in motion picture work, contact: *The International Photographer*, 7715 Sunset Blvd., Hollywood, CA 90045. Phone: (213) 876-0160.

10
Gallery Work

Interest in photography as a fine art has evolved with surprising speed. Ten years ago, the idea of an art gallery devoted to the sale of historic and/or contemporary photographs seemed an impossible dream. Several dozen or more were started, only to fall prey to bankruptcy everywhere except in such major cities as New York. Even on Manhattan Island, where a dense population and publishing center resulted in unusual interest, failure of such galleries was extremely common.

The change in this situation was caused by a number of factors. The economy went into chaos and people began to think they could no longer trust such traditional investments as stocks and bonds. Collectibles in general became popular among investors. Auctions were held and old photographs were among the offerings to go up for sale. Within the first year or two that the major auction houses offered photographs, some of the items were put up for sale two or three

times with each sale bringing a substantially higher price than the previous transaction. It was obvious that great profit could be made in this area and people began seeking photographs for purchase.

A second change came from colleges and universities, which began to offer photography as a fine arts subject, not just as a business course. Art majors began looking seriously at photography as the basis for a profession. Others took photo history courses for personal interest in the same way that many college students majoring in other fields take courses in painting and sculpture for personal interest. Such knowledge led many of them to collect pictures.

There were other reasons for this trend as well. A generation raised on picture weeklies such as *Life* and *Look* developed an interest in owning single photographs. Photography courses on the high school level also fostered an appreciation of the skills of professionals. Whatever the case, today a large number of galleries sell photographs exclusively. Even more galleries now sell photographs as part of their offerings in paintings, sculpture, and similar media. In addition, museums are hiring people to work with collections of photographs in their possession. The Museum of Modern Art (MOMA) in Manhattan has been a pioneer in this field. In fact, the "Family of Man" exhibit of photographs displayed by MOMA several years ago was reproduced in book form and became a best-seller.

John Szarkowski, director of the Department of Photography at MOMA, commented on what he seeks when looking for a new employee for the museum's photography section: "I would think that those hoping to pursue a curatorial career in photography should possess (1) a deep affection for photography and a broad understanding of its present and historic ideals and achievements; (2) a good art historical background, with emphasis on the study of Western art of the 19th and 20th centuries; (3) intellectual curiosity and an interest in the large historical and cultural issues of which the arts are a part; (4) reasonably well-developed intellectual tools, including the

ability to read and write English, and hopefully some compe-
tence in at least one other Western language; (5) a taste for
patient and systematic work; (6) responsible character; and (7)
talent.

"This is, needless to say, asking a great deal, and I don't
mean to suggest that I would myself score very high on this
test. Nevertheless, I think these are the qualities one would
look for. Some of them can be learned in any one of many
good schools, and some of them probably can't be learned at
all."

In talking with gallery owners around the country who
have been in business more than the two years during which
bankruptcy poses the biggest danger, I have found certain
consistent keys to success. One is an understanding of the
history of photography. This is learned through a combina-
tion of college study and personal reading. Courses in these
areas are taught in schools that may offer very poor technical
training, so a good school for a potential studio photog-
rapher will not be sufficient. For example, the University of
Arizona in Tucson has one of the best art history programs
related to photography. The Center for Creative Photography
is a major archive in which both the photography and the
personal lives of great photographers can be researched. One
of the professors is a world-renowned photo historian and
former successful gallery operator with museum experience.
Yet if someone wants to take pictures professionally, the
University of Arizona curriculum will not be adequate. The
school is a training ground for photo historians, critics, and
gallery workers, not professional photographers.

A second key to success is recognizing the market in which
you will be working. The sale of other people's photographs
is too new a profession for gallery owners to allow for prima
donnas who want to offer "the greatest work," which just
happens to match only their personal taste. It is important to
understand the market area and to offer what the buying
public seeks, even when you may not like it personally. You
have to recognize quality in fields you might dislike so that

you can truly serve local needs. In larger cities, a broad range of work, both historic and contemporary, may be necessary to handle local collector demands.

A third factor is your ability to work with the general public. Many professional photographers are basically withdrawn individuals who have a tendency to use the camera as a wedge between themselves and the world around them. They communicate through their images rather than through verbal interaction. The gallery owner, on the other hand, has to relate well to others since the job is that of salesperson to a great extent. However, it is a sales job that requires advanced historic, artistic, and technical knowledge, which is why it can be such a desirable career.

Another area of concern is an understanding of the technical process involved in photography. Photographs are made with chemicals that can be self-destructive over time. This is especially true for color prints. An understanding of archival processing and storage is essential if you are to preserve and protect images that already may bring prices in six figures.

Art photography courses, such as those available at the University of Arizona, usually include instruction in archival storage methods. A number of publishers, including Eastman Kodak, have produced books that relate to the handling of photographic materials for long-term storage and preservation. This knowledge must be considered basic for such a career, though it can be self-taught if the college training you receive does not include such information.

There are several ways to work into a career in gallery work. One is to go to work for a gallery or museum in any capacity. This can be done while you are in school or you might want to wait until you graduate. What is important is that you gain an entry that will give you some experience in gallery operations. Keep in mind that in many museums even working as a guide requires at least a bachelor's degree, even though the job brings the lowest salaries in the business.

A second approach is to open a gallery of your own, in a sense, by starting a photography division of an existing art

gallery. A larger art dealer may be interested in taking on someone who can demonstrate training in the field and a willingness to work. You may have to work for minimum wage or even just for commissions. However, such an experience is very beneficial.

A third method is to work for a college or university that has a strong photography program and its own exhibit areas. The latter might be spread throughout the school or centralized in an actual museum connected with the school. This combination of academic and gallery work can give you a valuable education beyond college that will pay off when you apply for a job elsewhere.

However you choose to break into the field of gallery work, the first step is to obtain the proper education. Self-taught photographers must realize the need for additional instruction and must also be willing to take extra business courses as needed. The earnings can be quite modest compared with other careers, but the other rewards, such as being able to handle the works of great creative photographers, make the field desirable for many.

11

Fine Art Photography

It is hard to call fine art photography a career since so few individuals have been able to earn a living exclusively in this field. Ansel Adams is one photographer who has become extremely successful with such work, but his success is a rarity. Most people find that they must have full-time or part-time jobs as well, engaging in photography whenever they can and letting the sale of such work supplement their income.

An exact definition of fine art photography is probably impossible to pinpoint. The easiest way to define it is to say that it is photography sold in galleries for hanging on walls rather than for reproduction. However, many news photographers have taken individual pictures that are sold by galleries, and an increasing number of magazines will buy scenics, experimental, and other so-called fine art work for their pages.

For the purpose of this book, it might be a good idea to define fine art photography as something that is done for love rather than for a specific assignment. An individual image

rather than a photo series is taken, and that image is not meant for publication as an illustration for a book, magazine, or newspaper. Rather, it is designed for hanging on the wall and is normally sold through an art gallery or gift shop, or even from the wall of a restaurant that has agreed to display your work.

The prices paid for fine art photography have risen greatly in recent years. However, it is still a field in which a low profit margin and high volume of sales are necessary for the success of the majority of photographers. Only individuals who have established a regional or national reputation are likely to command even a few hundred dollars for a photograph. The majority of buyers are interested in the beauty of the picture and not in any potential investment that might result in a profitable resale.

The first step toward taking pictures for galleries and similar businesses is to decide what your costs will be. The fluctuating price of silver means that black-and-white prints are no longer necessarily cheaper than color. However, color images may fade with time, and how fast they fade is determined by where they are displayed and the color chemistry used. For example, at this writing, the most stable color work readily available is the Cibachrome process. Yet even Cibachrome provides a life of from just a few months to a few years without risk of some fading from exposure to sunlight or daylight fluorescents. This means that the buyer cannot be led to think that a color picture will necessarily become a treasured heirloom.

Black-and-white prints have a potentially longer life when properly printed and fixed. Archive-processed black-and-white images have the acid removed or neutralized and are not placed in contact with anything that could be destructive. This method of printing is offered by a number of custom labs and is easily learned at home if you choose to do so. Such images should last 100 years or longer. Even normally printed black-and-white images are liable to outlast the interest of the people buying them by a wide margin.

The cost factor will be determined by the place where your work is sold. Some galleries accept only loose prints, mounting themselves. Others want mounted prints without frames and still others want framed photos. Your work will have to be framed if displayed in a restaurant or other business.

What is the cost of photographs printed in 5-by-7, 8-by-10, 11-by-14, and 16-by-20 sizes? Prints that are smaller than 5 by 7 or larger than 16 by 20 seldom sell well. Determine the cost for black and white and for color. You should plan to use the Cibachrome process with slides and a good custom printer if working from negatives. Slides are preferable for color because they can also be sold to publications. The final prints will look quite similar to those made from negatives, so the use of the slides will not hurt you in any way.

Include in your cost figures expenditures for film, initial processing, and mailing if you send your work out to be printed. Naturally you will not want to include the price of an entire roll of film when figuring the price of one slide. You should base this figure on whatever percentage of the images are salable. If you took a thirty-six-exposure roll and have six images that will be displayed in galleries, you should include one sixth of the cost of the roll as part of the expense for the print.

Finally, decide what a frame will cost. Price different frames and consider making your own as an alternative. See what seems most reasonable without sacrificing effect. Keep in mind that if you matte the print, you should use an acid-free matte paper. This is because an acid paper will eventually affect the print, causing it to turn color or otherwise deteriorate.

The preservation of your work is critical, and Eastman Kodak, among others, has booklets available on proper ways to mount photos for long-term use. Many photographers think that rubber cement or a similar, seemingly safe adhesive will be effective. They do not realize that the chemical action on a black-and-white print alone can result in the image turning yellow within about a year if rubber cement is applied to the back of the picture.

Once you know your actual costs, you will be able to determine the places where you can offer your work for sale. If the type of picture you want to offer costs $25 by the time it is printed, mounted, and framed, then you cannot expect to sell it in a gift shop whose average sale is under $20. It would, however, be ideal for hanging in galleries where prices of $50 and up are paid regularly. The customers entering the gallery will already anticipate those price ranges.

Keep in mind that people buy for one of two reasons for the most part. The factor motivating the majority of individuals is aesthetics. In other words, a picture is purchased because someone likes it. The image has value only because of the desire to own it for hanging on the wall. Usually such a buyer has a set maximum that he or she will pay and, if your picture is too expensive, someone else's work will be bought. The person does not care who took the photo and will not be impressed by a name.

The second common motivating factor is a relatively minor one. The purchase is made in the name of prestige, whether as an investment or as a means to impress friends who are knowledgeable in the field. The person buys an Ansel Adams, an Edward Weston, an Henri Cartier-Bresson, or a work by someone else whose reputation is well established. Sometimes the selection is also made for aesthetic value, but appearance is usually secondary to the fact that the owner will be able to say, "I own a Timothy O-Sullivan Civil War image." The specific O'Sullivan print is of no importance. It is the photographer's name, intended to impress others or to trigger resale at a profit, that matters. Such people will probably not buy your work even when they can afford it and actually prefer the images you are producing to those of the big-name photographers.

A fine art photographer usually operates in one of two ways. Some individuals specialize, trying to gain a reputation in a relatively narrow field for gallery work. For example, Diane Ensign-Caughey is rapidly becoming well known in galleries for her nature and wildlife photography. She earns

her living handling all the assignments she can get, doing weddings, portraiture, and similar commercial photos. However, her main love is wildlife images, most of which are sold through galleries and, to a lesser degree, through publications. She wants to be known as a wildlife specialist and refrains from showing other work in galleries while she builds her reputation.

Other fine art photographers do not specialize. They cannot afford the type of traveling Diane has to do in order to have a large enough selection of constantly changing images built around the same theme. Instead, they photograph scenics, close-ups of flowers, abstract colors, people, old buildings, and anything else they feel will interest others. Often these are totally unrelated images which does not matter since few galleries specialize in one type.

Next, each photograph is enlarged to whatever size seems appropriate. Then they can be carried loose in a box or placed in a portfolio. The portfolio reduces the risk of damage, but gallery owners are accustomed to seeing boxed images as well, so how you present them will not seriously affect your sales potential.

Call the galleries in your area for appointments. Talk with all galleries that handle photographs, of course, but consider every art gallery a potential customer. You should also check with museums and galleries operated in conjunction with area colleges and universities.

Gallery owners will seldom buy your work. Instead, you will be allowed to show it, often by paying a modest hanging fee, or to leave it on consignment for a minimum of thirty days. Work left on consignment will be exhibited either until sold or for the agreed-upon period of time, then returned to you. Revenue from each sale will be split according to whatever arrangement is made. The percentage the gallery receives usually is determined by its expense. A gallery that provides framing will always take a larger cut than a gallery that requires you to supply framed images.

There are other places to go besides local galleries. Banks,

restaurants, and other businesses are often willing to display your prints, including your business card so that people can call with an order. Work that is specialized can be shown in businesses related to that area. For example, animal and pet pictures might be displayed on the walls of a veterinarian's office or a pet supply store. Sports-related photos can be shown in sporting good stores.

You will need to frame photographs displayed in businesses. The business supplies the space and uses the images to attract customers. You are charged nothing, but the business will not take orders. Everyone will be referred to you, and the phone number on your business card should be one that will be answered at all times. If you have no such number because of your work situation, use an answering service or an answering machine.

There are still other markets for sales. Flea markets, swap meets, and fairs can be good prospects. Some churches might be interested in selling the pictures if the church takes a percentage. The best religious organizations to contact are those that have bookstores, gift shops, or art galleries connected with their facilities.

Pictures taken in a specific location often can be sold through souvenir shops related to that location. One fine art photographer of my acquaintance is in love with zoos. He has been selling zoo pictures to galleries for many years. When he talked with the manager of one zoo's gift shop, though, he discovered that the shop was delighted to display and sell his work. Now his pictures hang throughout the zoo. They are sold in the gift shop and a number were purchased by a foundation for use as wall decorations.

The same situation may be found in amusement parks, public parks with private tourist shops, and similar locations. Photographs make for a popular souvenir when priced within the buyer's budget.

Another method used by fine art photographers is to have some pictures made into postcards by one of the companies specializing in this work. The cards are sold in quantity and

often are purchased by restaurants, hotels, and the like to give away to customers.

There are two annually updated guides that will help you find galleries, fairs, and other locations that might be interested in your fine art photographs. These are *Photographer's Market* and *Craftworker's Market,* both published by Writer's Digest Books. The market guides, available directly from Writer's Digest Books in Cincinnati and through larger bookstores, provide all the information you will need to exhibit and sell outside your community.

Poster companies are another source of potential sales. These companies usually prefer fine-grained images, though 35mm Plus-X works perfectly for them. *Photographer's Market* is a good source of such firms as well.

Some fine art photographs are equally appropriate for magazines. A number of publications use fine art images for insertion between normal features. Others, which are specialized, like to see single images that are dramatically beautiful and related to the magazine's subject matter. These are publications that might stress wildlife, flowers, or some other subject.

Photographers interested in sending fine art photographs to magazines should check the publication's interest by reading *Photographer's Market* and *Writer's Market.* both of which list such publications. Then send from one to perhaps six different appropriate images to that magazine. These should be black and white unless you are certain the publication can use color. Most magazines limit color photo use due to the cost of reproduction.

Include a query letter when you contact the magazines. This letter should explain that you are a photographer whose work might be of interest to the readers. Say that you are sending it on speculation. Other images are available for the editor's consideration if there is an interest. If your work is appropriate for the scope of the magazine, well executed, and different from what is on hand, it will either be purchased or you will be asked to send more on speculation. Sending

photos on speculation means that there is no guarantee to buy anything despite any interest shown.

You must also send a return envelope for the work. This should be large enough to hold everything that will be sent back to you and it should be stamped with adequate postage to cover all costs. The envelope is self-addressed and included in the original package. If you do not send the self-addressed stamped envelope for the return, your work will remain with the publication or be thrown away. This is because the cost of operating a magazine or other publishing house is so great that the cost of returning a large number of submissions is prohibitive. You must supply the return postage, envelope, etc., at least until you are able to work on assignment.

Photographs should be either 8-by-10 black-and-white prints or color slides mounted in plastic pages. Do not send color prints, because the publications seldom can reproduce such images. The plastic pages have pockets that hold either twenty 35mm or six 120 slides. They are available from most camera stores and also from many hobby stores that sell coins and stamps. The holders for coins and stamps are designed to fit the same space as the 35mm images.

Slides should be sent to galleries in the same way they are sent to magazines when an out-of-town gallery requests samples of your work. If the gallery normally projects the images for study, have duplicate slides made and mail the duplicates, not the originals. Projection causes severe deterioration of color and can destroy a slide quickly. One study has shown that with a total viewing time of just twelve minutes in a projector, a Kodachrome slide will deteriorate noticeably, becoming unusable in as short a period as less than five years. A Kodachrome slide stored without projection, viewed on a hand viewer or with a magnifying glass, will last at least fifty years under normal storage conditions.

Fine art photography does not require special training, although the more you know about photography, the more creatively you can use the tools of your trade. General courses in camera work plus courses or books covering the history of

photography can be of help. They are not essential, however.

Although fine art photography is discussed in this book, it should not be considered a career that can guarantee all the income you need. Must such photographers teach at high schools and colleges, sell cameras, or hold jobs totally unrelated to photography. Their fine art photographs provide extra income as well as immense personal satisfaction. They would not work regularly for any publication or in any other field if it meant abandoning their fine art work because the bulk of the rewards are emotional and not financial for the majority of those engaged in such work.

12

Where to Get an Education

\mathbf{P}hotography education is an exploding field. Ten years ago most professionals learned through self-education, correspondence, trade schools, or perhaps half a dozen institutions devoted to residence training in photography. Today most large universities offer some form of photography major, which might be in the specialized areas of television work and/or photojournalism or a full fine arts major covering studio work or photo art history. The following sampling of recognized U.S. schools represents just a fraction of the training available, and you should always compare schools in which you are interested.

One important precaution to take when seeking photography training is to study the school's facilities, including equipment you will be using, studio space, and similar factors. A second factor to examine is the faculty. You should know the professional (nonacademic) experiences of the staff in the area you wish to study. Photojournalism should be

109

taught by someone who has published in newspapers and magazines. Fashion photography should be handled by someone whose background includes such work. An individual might be a brilliant photographer, but, if his or her experience is limited to the academic world, that person will not know how to teach you to compete in the real world.

Always talk to potential employers before making a final commitment. Remember that even the best training is meaningless if it does not help you gain those skills sought by the type of photography employer for whom you wish to work. Naturally the job market will change from time to time, and an employer's request for a specific background of study is no guarantee that you will get a job with the person when you are through with your training. However, a comparison of several potential employers in the same field will provide a good guide to what is generally considered an acceptable basic training program for anyone in the business.

CORRESPONDENCE TRAINING

New York Institute of Photography
880 Third Ave.
New York, NY 10022

The New York Institute program is among the best of the home study courses. The illustrations are effective learning tools, the information is sufficiently detailed to provide a sound background in professional photography, and you have the added pleasure of listening to cassette lectures and taped critiques of your work. The tape is a gimmick and will not increase your skills. However, it does give you the feeling of being more personally involved with the school and can make you enjoy learning a little more.

The drawbacks to NYI are those you will encounter with all other correspondence programs. You are limited by personal motivation and the equipment you own. You will receive intense training in areas for which you own a particular

camera, but information on different equipment will be merely theoretical. Also, there is little incentive to work beyond the basic assignments since there is no peer pressure as in resident schools. If you are not a self-starter, this is not the school for you.

School of Modern Photography
Little Falls, NJ 07424

The School of Modern Photography is the closest rival to the New York Institute, and trying to decide which program is better is almost impossible. The program is slightly different in that there is no tape recording involved and SMP offers special props for studying lighting.

In the past SMP has been much more business-oriented than NYI. Freelancing is stressed strongly and the school issues a regular newsletter that is extremely helpful both to the student and to the working professional. A recent revision of the NYI course has increased its focus on freelancing and studio business, bringing it more in line with the SMP emphasis.

My personal feeling is that you should contact both schools, study their literature and see which one makes you feel most comfortable. Both are excellent and the drawbacks to each are apparently identical. Personal preference will really dictate which way you go.

National Camera, Inc.
2000 W. Union Ave.
Englewood, CO 80110.

National Camera is a resident and correspondence school specializing exclusively in camera repair training. This is a major training ground for camera repair people who do not take courses in trade schools or camera manufacturers' training programs.

National Camera's correspondence school is limited in the amount of hands-on work you can do. You may have unrealistic job expectations after completing this course because your

knowledge will be extensive. However, repair shops want people with proven skills, and your equipment handling experience will not be extensive through correspondence.

Residence training is the best route to take with National Camera. Many repair shops around the country send excess equipment to National Camera for students to handle. The residence course involves almost an apprenticeship in terms of variety of opportunity, and this speaks strongly in its favor. If you decide to study repair through National Camera, try to go for residence rather than home study.

RESIDENCE TRAINING SCHOOLS

Arizona

The University of Arizona
Tucson, AZ 85721

Individuals interested in gallery careers, working in museums, photography history, and photography as a general art form have an unusual opportunity at the University of Arizona. Such courses are the pet of the current university president, who was the impetus behind the creation of the Center for Creative Photography.

The Center for Creative Photography is the resource that makes the University of Arizona unique. It is the repository for the photographs, negatives, personal letters, diaries, cameras, and other items of numerous photographers, including such individuals as Ansel Adams. It is one of the five or six largest repositories in the world and is unusual in its maintenance of the depth of material on each individual represented. Even videotapes of lectures by such famous photographers as W. Eugene Smith are included.

The practical application of photography through studio work and similar areas is not possible to study at this writing. However, someone connected with gallery photography will find the training among the best in the country. Equally important is the fact that the staff has extensive experience in

both the history of photography and gallery management.

Northern Arizona University
Flagstaff, AZ 86011

According to Manny Romero of the Department of Journalism, "The photojournalism curriculum consists of an extended major of sixty-three to sixty-five hours. No minor is required. The major includes courses in news reporting, public relations, advertising, editing, typography, mass communications law, magazine writing, and publications design."

The photography offerings begin with basic photography, which is a broader course than the name implies. It not only teaches the technical basics of taking pictures; it also provides students with information concerning the use of photography in communication. This is followed by a course in intermediate photography, which encourages both practicing creative efforts and learning darkroom techniques.

The course in advertising and public relations photography teaches students to use photographs as a means of promoting both products and businesses. The training is designed to provide students with the skills needed to obtain a first job with a photography studio specializing in these areas.

Photojournalism is taught from both photography and photo-editing standpoints. Students learn not only how to take pictures that provide visual impact while telling stories; they also learn about layout, design, and editing work. Students interested in utilizing other photographers' work most effectively, even if they do not take pictures, will benefit. The training can be applied to picture research and editing positions for newspapers and magazines. The proper way to lay out and reproduce photographs is also covered.

The multimedia productions course provides training in writing, designing, and producing shows involving a combination of slides and studio tapes. Such background can be used when preparing training programs for companies, handling assignments for educational institutions, and similar markets requiring this specialized type of presentation.

There is crossover training available in other departments. Among the areas students are encouraged to study are color photography and specialized still photographic techniques. The latter program introduces the students to large format equipment, posterization, and other less common techniques that are of value in a photography career.

Institutional photography is another course offering of the school. This is a program for nonphotographers who are going to be taking jobs in which an understanding of photography is essential. Such individuals include school teachers, public information officers, newspaper or yearbook advisors, and people using photography for publicity purposes. The idea is to combine the knowledge of writing and other skills with an understanding of how photographs can be used effectively.

The university has also developed a credit program involving internship. Students have on-the-job experience working for advertising agencies, studio photographers, publications, and simlar businesses that need staff photographers. They can also get credit for successful freelancing on their own, an area of special interest to the already skilled photographer returning to school for a degree in the field.

Phoenix College
Maricopa County Community College District
1202 W. Thomas Rd.
Phoenix, AZ 85013

Allen Dutton of Phoenix College commented, "Phoenix College has offered four semesters of photographic courses for the student interested in the arts and humanities. These courses are geared for the nonprofessional as a cultural enrichment program. Although the basics of the photographic process are taught, the emphasis is not on professionalism.

"In addition, you will note that we do offer two semesters of commercial photography, both in day and evening sessions. This offering is taught by successful and upcoming commer-

cial photographers who are Art Center (Los Angeles) graduates and who operate successful businesses in the area. These courses are geared to commercialism and they provide a service that seems to fulfill the needs of the community."

California

University of Southern California School of Performing Arts
University Park
Los Angeles, CA 90007

The name of the school tells everything. Cinematography and television production are the specialties of this division of USC. The training is excellent and the location, in the middle of the television and motion picture industries, allows opportunities for part-time jobs to add to your learning experience.

Chaffey Community College District
5885 Haven Ave.
Alta Loma, CA 91701

The course description for Chaffey College states, "An 'Emphasis on Photography' prepares for a variety of careers in photography as well as in related areas such as lab work and retail sales. In addition to learning to take and process photographs in a variety of situations, students are prepared for work in the field of photojournalism, publications, portrait illustration, technical and scientific photography."

A study of the curriculum reveals that the statement concerning the course is an accurate reflection of what is offered. This is one of the few programs in which intense business training is part of the basic curriculum, for example. Such training is essential for anyone interested in commercial photography, retail sales, lab management, and similar fields.

The Glen Fishback School of Photography, Inc.
3307 Broadway
Sacramento, CA 95817

This is an unusual school. It is an independent photog-

raphy school founded by a professional photographer who died a few years ago. It is aimed at the person interested in personal independence, through either freelancing or operating a one-person studio. The program seems fairly extensive and does not require previous training. There is also fairly extensive equipment upon which to draw. However, students do have to own an interchangeable lens camera (35mm or 2¼ format) with normal, wide-angle, and moderate telephoto, a spotmeter, tripod, filters, lens shades, and carrying case. This is more than is necessary for many college programs but a realistic holding for someone seriously interested in a professional career. Large format equipment operation is taught and the equipment is available from the school.

The Hamilton School of Photography
2231 S. Carmelina Ave.
Los Angeles, CA 90064

This is a school whose main concern is commercial photography. Photojournalism is covered, but this is primarily applicable to annual report work and advertising uses. There is an equipment requirement, but it is minimal compared with that of many other schools. Darkroom training is provided, but this school is not equipped to train people interested exclusively in this field. However, it can provide an excellent general background in commercial work.

City College of San Francisco
50 Phelan Ave.
San Francisco, CA 94122

The department of photography provides extremely broad training with specialty areas covering most careers in photography. Both commercial photography and laboratory work are emphasized by the school. All careers other than scientific work are taught in the still camera field.

The school offers a cinematography major separate from the still work. This includes such specialized aspects as adding sound, editing, and scripting of motion pictures. Special effects work is also taught at the school.

California State University (Long Beach)
Long Beach, CA 90840

Two types of photography courses are offered at California State University, Long Beach. One course prepares you to teach photography in junior high and senior high schools. The second course major is aimed at the person who either wants to become a professional photographer or wants to utilize photography in a profession such as an area of fine arts.

Colorado

Colorado Mountain College
3000 County Rd. 114
Glenwood Springs, CO 81601

This school has a photography department devoted to commercial photography, darkroom training, and general freelance work. The staff has an excellent professional background and related business courses are available.

Connecticut

Central Connecticut State College
1615 Stanley St.
New Britain, CT 06050

One of the specialized areas taught by Central Connecticut State College is the field of media specialist. Extensive audiovisual training is available for preparation in careers relating to school work. However, the information is such that it provides an excellent background for jobs with audiovisual production companies.

Central Connecticut State College
New Britain, CT

This school offers photography and audiovisual training as an adjunct to other departments. Many photography courses are related to the application of photography to education, for example. This is the school to seek if you want a career in

which photography is merely an adjunct. However, at this writing, the training would not provide all that is needed to become skilled in commercial work, television production, and related fields.

Central Connecticut State College
1615 N. Stanley St.
New Britain, CT 06050

Photography is not a major as such in this school. Instead, photography training is offered in conjunction with other fields. It is extremely limited and not career-oriented at this writing.

Delaware

University of Delaware
Newark, DE 19711

John Weiss, associate professor of art and coordinator of photography, commented, "The University of Delaware offers a wide range of photography classes within the Department of Art. We offer two degrees for undergraduates: BA and BFA, and have a two-year graduate degree leading to an MFA. Our course work includes the traditional black-and-white classes, plus color, nonsilver, and a variety of special offerings such as The Creative Portrait, Exhibition and Portfolio Techniques, Photography as Illusion, and others. These latter courses are usually not continuing but are normally given as one-time classes, depending on the interest of students and faculty.

"Those of our students who find employment have normally been successful in two areas: teaching and museum internship. However, more and more we are exposing them to other possibilities, including history of photography, creative writing, curating our own gallery, publicity, and the like."

Florida

Brevard Community College
Cocoa, FL 32922

Brevard Community College offers what it calls the "Indus-

trial Photography Program." It is aimed toward those interested in photography as a career, those interested in using photography as a tool, and those who want to have it as a medium of creative self-expression. According to a prospectus sent to students; "For the student who looks to photography as a vocation, industrial photography technology is offered as a two-year terminal program. An industrial photographer is an individual using photography as a contributing tool in industry, governmental agency, educational institution, armed services, medical institution, or any photographic department where he is employed in-house and working for a salary. The principal product or service of his employer is something other than photography.

"In many instances the industrial photographer must be the most versatile of all photographers, since his jobs are likely to be more varied than either the portrait or commercial photographer, often making portraits and doing commercial assignments. The Industrial Division of the Professional Photographers of America lists more than 300 photographic tasks performed by industrial photographers, and these generally fall into two major categories. These are public relations and photographic documentation. Broad training is required that ranges from audiovisual presentations through photojournalism, commercial and portraiture, to such specialized photography as photoelastic stress analysis and photomicrography.

"The four semesters of the program should be taken in sequential order. The first semester represents an opportunity to learn or to review photographic basics, and to complete these support and general education courses needed prior to more advanced work.

"The second semester emphasizes work at a professional level in both black and white and color. Here the student must make the transition to the higher basic technical and aesthetic standards while directly meeting the needs of the client. The student may create personal photographic statements only within these parameters. This is often a difficult period of self-examination for those wanting to compete in the professional photography job market.

"The third term is a rigorous photographic experience with courses in the three major classifications recognized by the Professional Photographers of America, Inc. These are: commercial, with emphasis on lighting and selling a product; portraiture—lighting, posing, and camera room psychology; and industrial, with emphasis on documentation and public relations. Here the student is additionally challenged with increased productivity and timeliness as well as professional quality standards.

"The fourth semester provides an opportunity for specialization, for examination of specific career areas, and preparation for continued education, whether formal, on the job, or in a preceptorship. The operation and economics of professional photography are studied in the operations course. This is believed by many experienced photographers to be the most important element of a professional photography education. It develops in the student an awareness of the need for financial success in any photographic enterprise under our economic system."

Fred Siegrist, an associate professor for the department who wrote the previous material, points out that the training can also be used in the field of biomedical photography. The school has contacts that enable graduating students to enroll in special programs with several hospitals. After from six months to a year of training, the student is able to begin a career in the biomedical field. This is unusual among many schools and well worth considering if this is your interest.

Idaho

Idaho State University
Fifth St.
Pocatello, ID 83201

Much of the photography training here is connected with the journalism department, and it is fairly extensive. Both television photography and still work such as photojournalism are covered. Basic photography training is meant primarily for those with no background who will be combining it

with other courses in journalism. Darkroom training is extensive enough to allow you to gain a first job in processing work if that is your career goal.

Film production training and television camera work are also covered. The courses are excellent for someone who wants a broad audiovisual background.

Illinois

The School of the Art Institute of Chicago
Columbus Dr. and Jackson Blvd.
Chicago, IL 60603

At this school the emphasis is on photography and video as fine arts. The training will expand a photographer's creativity and provide a solid background in photography for someone who wants to use it in conjunction with another job. However, the courses listed at this writing seem of limited use to someone who seeks a career behind the camera or in gallery work.

Ray-Vogue School of Design
750 N. Michigan Ave.
Chicago, IL 60611

This school offers the chance to explore every type of career in photography. However, the nature of the school is such that the training is most effective for jobs in commercial photography, sales, and technical work, such as darkroom work. There is training in photojournalism and scientific photography, but the job requirements for careers in these fields often require broader training, as you have seen. The school's training coupled with broader studies in a college or junior college would be ideal for these fields in order to ensure that you have prepared yourself as well as possible for a potential employer.

Columbia College
600 S. Michigan Ave.
Chicago, IL 60605

Columbia College's program was best described by Hanna

Eiler, administrative assistant in the Departments of Art and Photography. She stated, "Columbia offers a four-year photography program that prepares the student for any job in the photography field, depending, of course, on individual skill level and performance. In order to further educate the serious photography student, Columbia College will be offering a master's program in photography"

The college's program is broad and, by taking courses in other areas at the school, you can prepare yourself for all the careers covered in this book. It is typical of the type of training found only within a large institution that has devoted itself to the establishment of a serious photography department aimed at practical careers in the field.

Northern Illinois University
DeKalb, IL 60115

Hallie Hamilton of the school's Department of Journalism wrote; "We offer (at NIU in the Journalism Dept.—which is in the Liberal Arts and Sciences College) a sequence or emphasis on photojournalism. The photo courses directly involved are called Press Photo, Advanced Photojournalism, and Picture Editing. We see photojournalism as the combination of writing, layout, and photography for an effective communication package—whatever the format/purpose. This is interpreted to mean that students try to develop the basic journalistic skills of writing, editing, reporting, photography, and layout. Those skills are then coupled with some knowledge about such things as law, theory, social responsibility, and ethics. This would also suggest that the idea is that the student has more ways to use the skills than, say, a student who is a reporter or writer. This also means that the student probably can bring more skills to bear on communications problems and more skills available to employers.

"Independent study, internships, and our broadcasting programs (courses) also are ways within the department to practice and further understanding of skills. Further, the

university has photo (cine and still) in the Industry and Technology Department, as well as the Art and Speech Communication departments.

"Jobs—obvious ones are fairly direct—publication, studio, freelance, advertising, self-fulfillment. Where—seems like anyplace that must communicate with masses. We have people in newspapers, magazines, TV, advertising, studio, specialized press, teaching, self-employed, insurance, public utilities, design, research, law, radio, museum director, forest ranger, fire fighter. I am not trying to be flip; I am just saying that skills are used in as many ways as people can think of—in some cases directly and in other cases indirectly.

"Our department is accredited with AEJ (Association for Education in Journalism) in three sequences—public relations, news editorial, and advertising. We offer emphasis sequences in those three areas as well as in photojournalism, magazine, and specialized press. Broadcasting and photojournalism will be submitted for accreditation in the 1980s.

"As in other areas in the department, we try and have been successful in getting faculty . . . that has professional background in photo and other journalistic skills. At this point we have two on the photo staff in photojournalism—myself, with thirteen years of experience in the newspaper and industrial journalism fields and twenty-one years of teaching and running the program. My current faculty colleague is a twenty-five-year Navy photojournalist (retired). We have a civil service lab supervisor and a student who help to run the program in very good facilities."

Western Illinois University
Macomb, IL 61455
Photography as an undergraduate program has come only recently to Western Illinois University. The courses are quite general in both still and motion picture photography. However, the coverage is so excellent for a new program that this school is worth checking if its location is convenient for you.

By the time you read this, the course may have been expanded to a level at which practical training in professional career areas is possible.

Southern Illinois University
Carbondale, IL 62901

This school has courses in almost every career field related to photography. There is extensive photojournalism training as well as full commercial photography instruction. The latter lacks business, but students are encouraged to take business management courses through other divisions of the university.

Motion picture production training is extremely practical. Students learn to handle industrial work, training films, documentaries, and commercials. Similarly broad courses of study are available in television production. Both fields are coupled with internship programs in the community, which allow students to obtain practical training with professional companies in the field.

Fine arts photography training is available in conjunction with the art departments. This provides training in the graphic arts and for people who want to use photography in relation to other fields.

Scientific and technical photography training is also available. Medical photography can be studied through special courses related to the medical school of the university.

Indiana

Ball State University
Muncie, IN 47306

This school offers three primary training areas in photography and they all are effective. One is photography training, which is applicable to a career as a commercial photographer. The second is aimed at those interested in cinematography. The third is designed for the person interested in publishing, especially in general photojournalism. The training can be applied to other careers as well by combining it

with courses offered by other departments of the university.

Iowa

Hawkeye Institute of Technology
Box 8015
Waterloo, IA 50704

This is an unusual school in many ways. It is one of the most comprehensive, especially in terms of commercial training, which seems to be the school's specialty. Even basic business communication skills are covered, which are essential to success and can be overlooked. There are courses in technical writing, portfolios and job seeking, and other areas of business that will ensure excellent preparation for career work.

The school is also unusual in its requirements. It owns extremely varied expensive equipment but is obviously trying to limit what it provides by seeing that the students own compatible cameras at the start. This can be costly for the student. For example, the first quarter requirement is that a student own the following:

35mm Nikon camera with 50mm lens
Sekonic L-28C, L-428, or L-398 light meter
Heavy-duty tripod (must be strong enough for view cameras)
Lens hood for 50mm lens
Adjustable neck strap
Cable release for Nikon
Synch cord
Yellow and red filters (52mm screw-in for Nikon lens)
Three 4-by-5 film holders
Lens brush or ear syringe blower
Two 35mm 36-exposure stainless steel developing reels (Nikon
　　style)

The school itself supplements this equipment with an extensive range of Nikon lenses and accessories. The school also has Hasselblad equipment, specialized roll film cameras, a

Leica M-4 system, twin-lens reflex cameras, and both 4-by-5 and 8-by-10 view cameras and lenses. The school maintains extensive lighting and flash meter equipment for use by students as well.

When the student starts the third quarter of training, he or she must also possess these items:

4-by-5 view camera with case
210mm lens mounted on lens board for above camera
Three additional 4-by-5 film holders (six required)
Cable release for view camera lens
Synch cord for view camera lens
Focusing cloth for view camera
Agfa-Lupe eight-times magnifier

The total cost of all this cannot be estimated. At the time of this writing, an additional expenditure of $2,000 for personal equipment is a realistic consideration. This is in addition to the course fees. The equipment recommended is usable in the standard studio facility, so it does have practical application beyond the school's training program. The only problem will come if you are on a limited budget when entering; this can be a serious drawback and should be considered in your decision on where to take your training.

Kentucky

Northern Kentucky University
Highland Heights, KY 41076
Photography with still camera equipment is not a strong point of this school at this writing. The courses are rather general and primarily confined to the art department. However, the training in broadcasting with emphasis on television is an excellent program. If this specialty is desired, this is a school to consider.

Western Kentucky University
Bowling Green, KY 42101
This school is extremely practical in its training in the

fields of photojournalism, television, and commercial photography. The instructors for the photojournalism classes, for example, are all experienced professionals. Some schools use theorists who have done no work in the nonacademic world. Western Kentucky, at this writing, insists that the instructors prove themselves in day-to-day competition on newspapers and magazines before considering them for jobs as teachers. Thus, the knowledge imparted may be more practical than that provided by many other programs.

Murray State University
College of Industry and Technology
Box 2456, University Station
Murray, KY 42071

Photography is a major part of the graphic arts technology department here. There are courses in commercial photography and the technology of photography as it relates to publications and printing. Courses include "Process Color Separation" and "Advanced Photolithography" along with more traditional industrial topics and photography fundamentals.

Maryland

Monte Zucker
10887 Lockwood Dr.
Silver Springs, MD 20901

This is a school that is not a school. Monte Zucker is a professional wedding photographer who, like a number of other professionals, operates periodic training programs throughout the United States. Courses are held in different cities each year. Each is planned so that it is accessible to individuals from a large surrounding area.

Wedding photography is one of those specialties not taught by the average photography school or training program. It is not difficult to learn the basics and some of the more unusual techniques applied in wedding work. Most of the skills are developed through practical application of the information,

but few schools provide the basic knowledge these traveling courses present.

The two-day session offered by the traveling course covers ways to handle posing and lighting while developing a unique competitive style. The idea is not to learn to imitate the Zucker style but rather to develop a personal approach based on concepts Zucker has utilized over the years. Subjects include pricing, packaging, posing difficult subjects, lighting for all indoor and outdoor weddings, and more. Sales approaches designed to increase a photographer's market and earning potential are covered. If you bring along albums that show your past work, that work will be evaluated as an additional learning tool.

Some cities have three-day sessions. This third day is devoted entirely to marketing concepts. It is usually taught by a psychologist and business consultant.

Courses like this are well worth taking. Commercial studio owners can gain new ideas. Beginners learn tricks that can help them develop an appearance of being more experienced than they actually are.

The business aspects of the workshops are also of value. They provide a background of information that is especially worthwhile during difficult economic times.

Massachusetts

New England School of Photography
537 Commonwealth Ave.
Boston, MA 02215

The training here is ideal for the individual interested in studio work or in applying photographic methods to other art forms. There is training in documentary photography and photojournalism, though an individual interested in a journalism career should obtain a broader education, perhaps through junior college courses. The camera equipment available through the school is somewhat limited, based on catalog information, though the studio facilities, lights, and darkroom seem excellent for the training being offered.

Hallmark Institute of Photography
At the Airport
Turners Falls, MA 01376

This school offers a good general course in all phases of photography. It has a strong business orientation, which is ideal for commercial photographers and those interested in management careers in a wide variety of photography-related fields. For example, there are courses on employee relations, employee motivation, employee compensation, contracts and proposals, marketing, selling plans, allied products related to photography studios, advertising, market analysis, and numerous others. The curriculum for the business aspects of photography, so often played down by photography schools, is excellent. Few photographers care about such courses until they realize that their artistic abilities and technical skills will not compensate for poor management. The regular photography training is equally excellent, thus making this school well worth considering if commercial photography or a related field is your area of interest.

Massachusetts College of Art
364 Brookline Ave.
Boston, MA 02115

The training program at Massachusetts College of Art primarily covers two fields—commercial photography and cinematography. A number of the still photography courses offer the training needed for a career in museum work. Extensive audiovisual equipment and television production equipment are also available in the courses offered by the Media and Performing Arts Department.

Endicott College
Beverly, MA 01915

This school offers training in several fields. However, the strongest areas are commercial photography and photojournalism. The commercial photography section is extensive enough that a separate training program in portrait work can be offered. However, unless you live in an area where a

portrait specialty can be a lucrative business, you should cover
the other commercial fields offered such as product, fashion,
and industrial work.

There is also training in fine arts work and photography
history. It is possible to gain the type of background that can
be the basis for a career in museum and gallery work, though
more extensive study, either on the job or in other schools,
will be necessary.

Michigan

Central Michigan University
Mount Pleasant, MI 48859

This school offers a reasonably complete course in photog-
raphy as it applies to journalism. The courses, combined with
other training available throughout the university, provide an
excellent basic background for the communications field.
Commercial photography training can also be obtained here.

Minnesota

University of Minnesota
100 Church St. SE
Minneapolis, MN 55455

Carol Pazandak, assistant to the president, wrote:

"The University of Minnesota does not offer a comprehen-
sive field of study in photography. Such courses are relatively
expensive to teach, and demand for them is extremely high.
There are a few courses in the Studio Arts Department, with
enrollment primarily reserved for majors in studio arts. The
offerings do include a sequence on film making for advanced
undergraduates and graduate students in other fields, but we
do not have a full program in film.

"Within the School of Journalism and Mass Communica-
tion, which is a program within the College of Liberal Arts,
there is a major sequence in photo communication. Students
completing this sequence are prepared for work on newspa-

pers and other news media. There is an active placement office and most graduates find related work. All graduates of the School of Journalism must meet the requirements of the school and of the College of Liberal Arts. Enrollment in the program is limited, and students must complete liberal education prerequisite courses and pass qualifying exams in written English and in typing. The School of Journalism ranked as number one in the country in the last accreditation ranking.

"There are some courses offered in the general college primarily for the nonprofessional who desires some background in photography, and some courses are taught through the university's evening class program."

Metropolitan Community College
1501 Hennepin Ave.
Minneapolis, MN 55403

Frank Agar, Jr., instructor of photography, commented; "We are presently teaching Photography I, II, and III—that is, beginning, intermediate, and advanced.

"We also have one course, History of Photography, which is taught in the Minneapolis Institute of Arts, near our college in Minneapolis.

"We do not train students specifically for jobs, per se. Our courses offer a solid beginning for them to pursue photography at the University of Minnesota, or possibly the College of Art and Design."

Missouri

Union of Independent Colleges of Art
UICA Information Center
4340 Oak St.
Kansas City, MO 64111

This is not a college but an organization of schools that includes Atlanta College of Art, California College of Arts and Crafts, Center for Creative Studies—College of Art and Design, Cleveland Institute of Art, Kansas City Art Institute, Maryland

Institute College of Art, Minneapolis College of Art and Design, Philadelphia College of Art, and the School of the Art Institute of Chicago. The address provides a clearinghouse to direct you to the nearest affiliated school offering the specific training you seek. The courses available through the member school can teach you everything from practical photography for a commercial studio operator to the management of an art gallery. Write to the clearinghouse, expressing your personal interest, in order to get a referral to an appropriate educational facility.

Kansas City Art Institute
4415 Warwick Blvd.
Kansas City, MO 64111

This school offers excellent training in the audiovisual field. Students have access to still and motion picture camera equipment as well as to videotape equipment. Thus, there is hands-on training in a variety of areas. The background obtained is applicable to both television stations and commercial studios. Again, business training is advised as additional background preparation.

New Hampshire

Keene State College
Keene, NH 03431

The courses offered are extremely limited. At this writing, the training is meant to provide a basic understanding of the medium of photography.

New Mexico

Department of Journalism and Mass Communications
Box 3J, New Mexico State University
Las Cruces, NM 88003

The name of the department reflects the type of careers the school's training prepares you for. The department offers an excellent selection of courses, with subjects ranging from photojournalism to television camera work to cinematog-

raphy. Everything from broadcasting to advertising is covered by the school and a television station is operated on campus.

New York

Ithaca College
Ithaca, NY 14850

The School of Communications offers excellent programs in applied photography of all types. Still photography, motion picture work, television, and similar programs are all extensive. Commercial photography, broadcasting, news work, and related areas are also covered. The program is extensive and allows a student to study several different areas to gain the broadest possible background, an excellent provision for those interested in an audiovisual career.

Syracuse University
Syracuse, NY 13210

Syracuse contains the Newhouse School of Public Communications, which is one of the most versatile for training in photography and broadcasting. You can study courses related to professional photography, television, advertising, and similar fields. Photojournalism is also represented in the field of study. This is a school for individuals interested in working with cameras. Gallery training is outside its scope, though photo history and technical information relating to photography are available.

Military Photojournalism Class
Syracuse University
Syracuse, NY 13210

This course training is listed separately because it is done in cooperation with the military. However, as indicated by the annual student publication, *Reportage*, the quality of the training is high. The students show remarkable creative and technical skills in a broad range of fields. The students may be in the military, but the quality and breadth of their knowledge, evidenced by *Reportage*, indicates that they could successfully compete with civilian studios nationwide.

North Carolina

Duke University
Durham, NC 27708

The training at Duke is extremely limited. Photography is not a major subject and only a basic background is provided at this writing.

Appalachian State University
Boone, NC 28608

The training at Appalachian State primarily focuses on the use of stills, film, and videotape for purposes other than photographic careers. The courses mainly relate to art and education. Someone interested in studio work, broadcasting, photojournalism, and similar careers will not find such training at this school.

North Dakota

University of North Dakota
Grand Forks, ND 58201

Tom Deats, associate professor of journalism, commented: "Our course listings and offerings at the University of North Dakota are rather limited. We offer one very basic course in photography every semester. This course covers the basic mechanics of cameras, picture taking, and print developing. More advanced students can take independent study for up to three credit hours with the approval of the instructor.

"Our classes are designed to introduce the students to the fundamentals of photojournalism, but in no way are they intended to provide a complete photography education. In fact, it's our point of view that what good photographers need to know is pretty much what any other 'educated' person needs to know—and this kind of knowledge is not to be found only in photo courses. Because ours is an accredited journalism program, none of our majors takes more than one fourth of their total course work in journalism.

"For the photo course we use a basic manual written by us

for our use. We encourage outside readings. In the basic course the grade is based on a final project each student completes—a picture page for a newspaper or magazine that includes a minimum of five pictures, a theme, and headline and copy."

Ohio

Antioch College
Yellow Springs, OH 45387

Nancy Howell-Koehler, visiting photo instructor, wrote of the Antioch program, "Our work in both photography and film making (taught by Janice Lipsin) is within the art department and therefore relates to careers in art.

"We also have independent studies, which allow for those who have other majors to continue with photography after their basic course. For instance, the communications majors can elect an independent studies course, which then would be supervised by the photo instructor. There is one scientific photography course outside of the art department that is related to the science area.

"Because Antioch is a work-study institution, Antioch students have the opportunity to experience a great many photo-related careers during their intern work and become self-directed toward a goal. They return from their work better prepared to make career decisions and can apply their experience during course work. Because classes are small, each student is given a great deal of individual assistance in reaching his or her goals.

"Current course offerings: beginning, intermediate, and advanced photography; photo history; and contemporary methods courses such as photo bookmaking."

Oregon

Linfield College
McMinnville, OR 97128

The school's curriculum was best described by one of the faculty members:

"Basic photography (Art 240) provides the student with a solid foundation in photography, covering many technical fundamentals such as the use of adjustable cameras, light meters, black-and-white film developing, and printing. Additionally, lectures, discussions, and assignments are intended to increase knowledge of aesthetic or design concerns, familiarize the student with the history of the medium, provide the student with experiences for photography in various careers such as photojournalism, commercial photography, and many careers that require photographic documentation, such as archaeology.

"Advanced photography (Art 367/467) includes information about the view camera, photo silk screen, studio lighting, and numerous other light-sensitive materials. Both levels of advanced photography present several media and allow the individual student to choose a few areas of interest for serious exploration with supervision by the professor.

"Independent studies in specialized areas of photography are also offered through the art and chemistry departments. For example, several students with a scientific background have taken tutorials in photomicrography and in the structure of light-sensitive materials. Interested students may gain additional practical experience in documentary photography through work on the school newspaper or yearbook. Occasionally there are freelance job opportunities for photography students at Linfield.

"Other classes relevant to the photography student:

"Art 368, Graphic Communications I: basic graphic design and visual communication, including typography, layout, production of art for various reproduction processes, and designing for mass media.

"Communications 260, Media Production and Design: design and layout for newspapers and magazines. Introduction to printing processes, typography and the graphic arts.

"Although our course offerings in photography per se are limited, many of the courses necessary for an art major are also valuable to the photography student."

Pennsylvania

Pennsylvania State University
215 Carnegie Building
University Park, PA 16802
 Photojournalism is offered primarily to give students a basic background in photography when their major is actually journalism. It is training for the person who needs to understand cameras while working mostly in other fields. The more complete photography courses are offered through the art department and these are applicable to the audiovisual field and to commercial work.

Rhode Island

Rhode Island School of Design
2 College St.
Providence, RI 02903
 In this school the photography major comes close to receiving fine arts training. However, with the extensive facilities for training in cinematography, video, architecture, and related fields, the school is excellent for the person seeking a broad education. Audiovisual training is extensive and the school has the facilities to allow you to take additional courses in special-interest areas related to the arts. This school does not provide the training needed to run a small photo business or enter photojournalism, however.

Rhode Island School of Photography
241 Webster Ave.
Providence, RI 02902
 This school is totally oriented toward the practical side of professional photography. Commercial photographers will be delighted with the course—everything from business techniques to unusual negative and print retouching methods. You can learn to work in processing labs and in the advertising, photojournalism, and audiovisual fields, as well as any

other field relating to still camera use as a professional photographer. The student is expected to own a 35mm camera and light meter. The school supplies all other equipment, including cameras, lights, models, labs, electronic flash units, working studios, and other materials. If the illustrations used in the catalog are typical of students work, the training ranks with the best available anywhere.

Tennessee

Middle Tennessee State University
Murfreesboro, TN 37132

This school offers excellent training in both commercial photography and fields relating to broadcasting. Cinematography, photojournalism, and other areas are all covered by the school. Equally important is the availability of business courses, film history, experimental photography, and other areas for study that can broaden the student's background for a number of related careers.

Tennessee State University (East)
Johnson City, TN 37601

This school offers a general background in both still photography and motion picture work. It is not structured around a commercial photography career, but courses in the business department are available that can provide the additional background. The movie making segment includes special courses in documentary work, animation, and general film production, all of which are applicable to both television and audiovisual work in addition to normal movie production.

Texas

Amarillo College
P.O. Box 447
Amarillo, TX 79178

This is a two-year program designed to provide a strong

background in commercial photography work. It is a little different from many in that motion picture training is included, something that gives students a better-than-normal background for this type of program. All that is lacking in the basic training offered at this writing are business courses, which are essential for successful studio operation. However, it is possible to gain this additional training through other courses offered at the school and it is important to avail yourself of them.

Sam Houston State University
Huntsville, TX 77341
 This school offers extensive photographic training in still camera work, television and motion picture production. Scientific photography, studio work, and photojournalism are all covered. The school also offers extensive training in related areas, such as business, science, and similar activities, allowing for in-depth education in any career related to photography.

Utah

Weber State College
Ogden, UT 84408
 This school offers a broad range of photography courses and the curriculum needed to supplement your education in any field. Studio training is excellent and supplemental business courses are available. Scientific photography is offered with a broad range of science courses essential to those who want to work in the medical, engineering, or other scientific fields. Police photography training is available and there is a law enforcement training program in a separate department. Journalism, architecture, and other fields can be studied.

Utah State University
Logan, UT 84322
 The current course of study emphasizes photography as a

fine art. The training includes courses designed both for the commercial photographer and the individual interested in a gallery career. However, because this program is part of the art department, it would be wise to take business courses and other additional training from separate divisions of the college if a studio career is your preference.

Journalism training is available for additional skills. There is also a campus television station, though limited education is offered in this field.

Virginia

Northern Virginia Community College
8333 Little River Turnpike
Annandale, VA 22003

This school offers an excellent background in photography aimed primarily at the individual interested in running a commercial studio. The only courses missing from the program are those in business and marketing. Such courses are available through the business division and should be taken in addition to the others. Otherwise, the school's instruction appears to be extremely thorough.

Washington

Everett Community College
801 Wetmore Ave.
Everett, WA 98201

At this writing, Everett Community College offers rather general training in both still and motion picture photography as well as in photojournalism. Lacking are specific business courses essential to the operator of a commercial studio. Training programs such as the one offered through this school can be excellent. However, you may need additional courses in related fields to gain complete training.

Shoreline Community College, District No. 7
16101 Greenwood Ave. N.
Seattle, WA 98133

Denzil Walters, chairman, Humanities Division, wrote: "We have planned our photography courses to fit into two-year career programs and four-year university transfer programs. The primary two-year program, with the title Visual Communications Technology, is designed to prepare students for positions in advertising agencies, department store advertising departments, and art departments of big printing companies, as well as for work as independents. The photography courses offered as part of the college transfer programs are designed to parallel university courses in communications, typically called the newspaper editorial sequence or radio-television sequence.

"A student interested in photography and the VCT program would take courses that would make him or her familiar with the demands and possibilities of reproduction through printing. Courses in the program include printing along with art and photography. In the combination photography and graphic arts program, the student would take seven courses in photography.

"Our photography program is directed by Chris Simons, whose degrees include a BA from the University of Nevada and an MFA from Washington State University."

Wisconsin

Western Wisconsin Technical Institute
Eighth and Pine Sts.
La Crosse, WI 54601

This is a technical school and, at this writing, it does not emphasize photography as a career. However, courses are available in photography as they relate to various technical and medical fields. Training is oriented toward careers in printing, publishing, commercial art, and similar areas, or as a visual communication technician.

Marquette University
Milwaukee, WI 53233

 William Thorn, PhD, of the College of Journalism, stated: "We have a limited photography unit here, and its purpose is to prepare students for work in the field of journalism. Our offerings include a broad-gauged visual communication course open to sophomores in the university, which combines dark-room work and graphics laboratory work with lectures on the elements of photography and visual design. We also have an intermediate course taught in 2¼-by-2¼ format, which concentrates on the basic problems in photographing motion, using various lighting combinations, and working with various films and papers. We also offer an advanced course in photo-journalism, which concentrates on the application of these skills to the media. We offer, on occasion, an advanced course in studio lighting, 4-by-5 format, and product shooting.

 "In addition we have a broad film program geared toward commercial work with an emphasis on broadcast journalism. This program includes a set of newly revised courses. The first is an introduction to the moving image taught on videotape and Super-8. The second is a broadcast journalism course taught solely on videotape. The third is an intermediate film course taught on Super-8 and 16mm. The final course is an advanced projects course in which students produce funded films, usually about twenty minutes or so in length. The careers included in this field include photojournalism, commercial film production, educational film production, training films, advertisements, and public relations spots. In general, the film program, like the still program, services our majors in news, public relations, advertising, and broadcasting, but they also teach students from totally distinct areas in the university.

 "Our photojournalism students take at least one course in film plus the still courses."

OTHER SOURCES OF TRAINING

 Specialized skills must often be learned on the job. Many

times individuals in specialized professions work together to advance knowledge among all the members.

Biological Photographic Association, Inc.
P.O. Box 2603, West Durham Station
Durham, NC 27705

This is an organization comprised of individuals who are biological photographers for scientific organizations, hospitals, and related fields. Active members are defined as: "Any person professionally engaged in 1) the practice of photography in the biological sciences, or 2) the active supervision and administration of a department established for such practice, or 3) the teaching of photography as applied to the biological sciences shall be eligible to apply. Any person whose duties include the specification or utilization of photography as applied to the biological sciences shall also be eligible to apply, provided that such practice constitutes a significant and regular portion of his/her duties."

There are also affiliate members, student members, and sustaining members. The latter are organizations such as scientific equipment manufacturers, hospitals, clinics, and the like.

Professional Photographers of America
1090 Executive Way
Des Plaines, IL 60018

This is an organization of professionals who are primarily involved with different aspects of commercial photography. The organization provides a magazine and training programs for members. Periodic newsletters are meant for photographers specializing in different areas such as industrial, portrait, and so on.

Wedding Photographers International
P.O. Box 2003
Santa Monica, CA 90406

This organization endeavors to cover the one part of com-

mercial photography that generates extremely high income but is seldom adequately taught in schools. Everything from sales techniques to creative approaches to the photography of weddings is covered. Seminars, newsletters, and other sources of information are made available to the members.

13

Publications

There are a number of magazines you should check if you would like to read about different photography-related careers. The following is a partial listing of the more readily available periodicals. Others are available through the associations mentioned in Chapter 12. All will prove beneficial to you.

The Professional Photographer
1090 Executive Way
Des Plaines, IL 60018

This is the publication of Professional Photographers of America (PPA) and comes in two versions. One has special business information and is meant only for members of PPA. The other comes without the business tips.

The advantage of this journal is that it provides a strong background in the problems and solutions encountered when taking photographs as a professional studio owner. The articles may cover industrial work and weddings, plus aerial,

portrait, animal, and pet photography, among numerous others.

The Rangefinder Magazine
1312 Lincoln Blvd.
P.O. Box 1703
Santa Monica, CA 90406
 This is a professional photography magazine that operates independently. It is not affiliated with an organization but covers similar topics to the PPA publication. In recent months, emphasis on advertising and promotion have proven extremely beneficial and many photographers subscribe to this in addition to the PPA journal.

Studio Photography
250 Fulton Ave.
Hempstead, NY 11550
 This magazine is also similar to *Rangefinder* and *The Professional Photographer*. All three are competitors and the audience they try to reach is similar. However, approaches to professional photography are varied, and some assignments become routine if you are not regularly stimulated. Thus, it is always a good idea to read all three publications because the different approaches by the professionals whose work is published can stimulate creative thinking.

Photomethods—The Magazine for Visual Communications
 Management
Ziff-Davis Publishing Company
1 Park Ave.
New York, NY 10016
 This magazine emphasizes management and industrial photography, often for corporations that have photography departments. It is not meant for the commercial studio owner, though it may be of interest to such individuals because of the technical information provided. Audiovisual photographers

will find the publication of interest, as will those interested in the tools of scientific photography.

Technical Photography
250 Fulton Ave.
Hempstead, NY 11550
 This is a magazine for photographers connected with industrial, government, audiovisual, and motion picture work as applied to in-house training films, corporate presentations, and similar jobs. Most of the readers have careers in photography departments rather than at independent studios.

*Millimeter—The Magazine of the Motion Picture and
 Television Production Industries*
12 E. 46th St.
New York, NY 10017
 This is a magazine for people who make television programs and motion pictures, not for the fans. Articles cover techniques, equipment, legal problems, and similar areas essential for those in the business. This is a good way for someone to keep abreast of the latest developments in this field.

Journal of Evidence Photography
24 E. Main St.
Norwich, NY 13815
 This is the magazine for the Evidence Photographers International Council, Inc. It is a quarterly designed to provide information related to law enforcement photography and the photography of evidence in order to build a court case. Law enforcement and forensic photographers will find this a valuable tool.

Appendix 1

Where to Buy Backdrops and Similar Equipment for Portraits and Models

Always shop locally whenever possible. You will gain excellent business contacts and come out ahead of a discounted price from an out-of-town store when the shipping charges added to the cost wipe out your savings. When all else fails, the following are possible sources. Inclusion of company names does *not* constitute an endorsement of these businesses, however.

Concourse Products, P.O. Box 6, Plano, TX 75074.

Holly Enterprises, 7555 Woodley Ave., Van Nuys, CA 91406.

Jasper Furniture, 3190 Wade Hampton Blvd., Taylors, SC 29687 (Company specializes in furniture for posing props, too.)

C.P.I. Corporation, 1706 Washington Ave., St. Louis, MO 63103.

Grimes Products, P.O. Box 478, Fairfield, IL 62837.

Pierce Co., 9801 Nicollet Ave., Minneapolis, MN 55420.

Photographic Products, 13535 Crenshaw Blvd., Hawthorne, CA 90250.

Appendix 2

Where to Buy Albums, Frames, and Photomounts

Albums, photomounts, and display frames are often least expensive when purchased locally, especially when your volume of portrait and wedding business is fairly low. This is because you save shipping costs and avoid having to retain a large selection, as can be the case when a mail-order company has a minimum order requirement. Other times the direct-mail purchase is better. Comparison shopping through the mail will help you decide.

The following companies sell photomounts, wedding albums, and similar items through the mail. As with all companies mentioned in this book, inclusion of these firms does not constitute an endorsement on the part of the author or publisher. The listing is intended for your guidance, and you should check a firm and its prices before deciding whether or not to make a purchase.

Penn Photomounts, 5th and Main Sts., Darby, PA 19023.

Michel Co., 4664 N. Pulaski Rd., Chicago, IL 60630.

Crestwood, 3601 W. 71st, Prairie Village, KS 66208.

Album House, RD 1, P.O. Box 70-A, Marlton, NJ 08053.

Crown Products, 2164 Superior, Cleveland, OH 44114.

Callen Photo Mount Corp., 218 Ocean Ave., Jersey City, NJ 07305.

Albums Inc., P.O. Box 30312, Cleveland, OH 44130 or P.O. Box 29724, Dallas, TX 75229.

A.F.M. Inc., P.O. Box 32033, San Antonio, TX 78216.

Appendix 3
Postcard Companies

Among the companies that make postcards from photographs are the following. Please note that inclusion in this list does not represent an endorsement by the author or publisher. The listing is for your convenience and does not guarantee quality. A check with the Better Business Bureau in the community closest to the company is advised for the latest information on the firm.

Dexter Press, Rte. 303, West Nyack, NY 10994.
Boberg, 3806 N.E. 24th, Amarillo, TX 79107.
Kolor View Press, 3205 Ocean Park Blvd., Suite 100, Santa
 Monica, CA 90405.
H. S. Crocker Co., Inc., 1000 San Mateo Ave., San Bruno, CA
 94066.
Dynacolor Graphics, Inc., 1182 N.W. 159th Dr., Miami, FL
 33169.

Appendix 4

Markets for Freelanced Photographs

\mathbf{T}he following material is meant to assist readers of this book who, regardless of their career plans, want to freelance some of their photographs. For extensive, annually updated information, you should supplement this with books such as *Magazine Industry Market Place, Audiovisual Market Place,* and *Literary Market Place,* all published by R. R. Bowker, New York. These three volumes provide exactly what their names imply. They list magazines; companies involved with the manufacture, sale, and use of audiovisual equipment; and book publishers, associations, and others connected with these industries.

Two other volumes, also updated annually, that are of great help are the previously mentioned *Photographer's Market* and *Writer's Market,* both published by Writer's Digest Books, Cincinnati, Ohio.

If you are interested in working with public relations firms that often buy photographs for brochures, newsletters, article

illustrations, and other promotional purposes, the largest single source available is *O'Dwyer's Directory of Public Relations Firms,* which is updated annually. It is available through the J. R. O'Dwyer Co., Inc., 271 Madison Ave., New York, NY 10016.

Most book publishers are interested in buying photographs from time to time to illustrate books. Publishers specializing in photography often are not the best freelance markets, however, because the authors are expected to supply their own illustrations. Usually the greatest sales are made to companies that publish textbooks or illustrated dictionaries. Among the markets you might wish to contact are the following:

Allyn and Bacon, Inc., 470 Atlantic Ave., Boston, MA 02210
 (This is a textbook specialist.)
Ave Maria Press, Notre Dame, IN 46556 (This is a religious
 and inspirational book specialist.)
AVI, Astroport, Mineral Point, WI 53565 (This is a science
 book specialist.)
William C. Brown Co. Publishers, 2460 Kerper Blvd.,
 Dubuque, IA 52001 (This is a publisher of textbooks and
 religious education books.)
David C. Book Publishing Co., 850 N. Grove, Elgin, IL 60120
 (This is a general publisher utilizing fairly large numbers
 of pictures each year.)
Crestwood House, Inc., 515 N. Front St., Mankato, MN 56001
 (Publishes heavily illustrated books primarily for children
 with limited vocabularies.)
Delmar Publishers, 50 Wolf Rd., Albany, NY 12205
 (Publishers of vocational books and textbooks.)
Fideler Co., 31 Ottawa NW, Grand Rapids, MI 49503 (This is
 a specialized publisher involved with social studies and
 similar books. Large quantities of pictures are needed, but
 it is important to contact the editor concerning specific
 areas of interest before sending anything.)
Fitzhenry and Whiteside, 150 Lesmill Rd., Don Mills, Ontario,
 Canada M3B 2T5 (General and educational publishing.)

The C. R. Gibson Co., Knight St., Norwalk, CT 06856
(Illustrations used for inspirational books.)

Prentice-Hall, Inc., Englewood Cliffs, NJ 07632 (Extensive
textbooks, business and professional books.)

Silver Burdett Company, 250 James St., Morristown, NJ 07960
(Textbooks published in a broad range of fields.)

The University Press of Hawaii, 2840 Kolowalu St.,
Honolulu, HI 96822 (Contact in advance for specific text
needs.)

Whitaker House, Pittsburgh and Colfax Sts., Springdale, PA
15144 (Inspirational, Christian literature illustrations.
Scenics are primary needs.)

John Wiley and Sons, Inc., 605 Third Ave., New York, NY
10021 (Large buyer of textbook illustrations.)

Winston Press, 430 Oak Grove, Minneapolis, MN 55403
(Primary interest is in text illustrations.)

Zondervan Publishing House, 1415 Lake Dr., Grand Rapids,
MI 49506 (Religious and conservative books are the
primary market here.)

Many greeting card and poster companies are also interested
in purchasing freelance photographs. The needs vary from
month to month, so you should always contact them first to
learn current needs, whether color or black and white is
preferred and any special areas that are important to them at
the time. Among such companies are the following.

Amberley Greeting Card Co., 1738 Tennessee Ave., Cincinnati,
OH 45229.

American Greetings Corp., 10500 American Rd., Cleveland,
OH 44144.

Bio-Tree Productions, Inc., Box 6132, San Francisco, CA
94101.

Elliott Calendar Co., 1148 Walnut St., Coschocton, OH 43812.

Goes Lithographing Co., 42 W. 61st St., Chicago, IL 60621.

L.T.K. Plastics, Inc., 49 Congress St., Salem, MA 01970.

Mark I Inc., 1733-1755 Irving Park Rd., Chicago, IL 60613.

Mead Products, Suite 900, First National Plaza, Dayton, OH
 45402.
Norcross, Inc., 950 Airport Rd., West Chester, PA 19380.
The Paramount Line, Inc., Box 1225, Pawtucket, RI 02862.
Mike Roberts Color Productions, 2023 8th St., Berkeley, CA
 94710.
Warner Press, Inc., 1200 E. 5th St., Anderson, IN 46012.

Index

A

Acid-free matte paper, 102
Adams, Ansel, 100, 103
Amdur, Harry, 91
Archive-processed prints, 101
Architecture photography:
 advantages of, 25; avoidance
 of distortion in, 23–24;
 building a portfolio of, 30;
 of exteriors, 22–25; of
 interiors, 25–29; training in,
 31; types of, 22–23
Architecture photography
 equipment: cameras, 29–31;
 film, 27–28; fluorescent light
 compensating filters, 32;
 light meters, 32; lighting,
 31–32; wide-angle lenses, 24
Associated Press, 62
Audiovisual firms, varieties of,
 88–89

Audiovisual photography, types
 of training for, 89
Audiovisuals, uses of, 87–88

B

*Basic Photography for Fire and
 Arson,* 54
Bourke-White, Margaret, 57

C

Camera repair: and knowledge
 of basic electronics, 75;
 schools, 74, tools, 74;
 training and job
 requirements, 73–75
Cartier-Bresson, Henri, 103
Cibachrome process color prints,
 101

Cooperatives of photographers,
 65
Craftworker's Market, 106
Crime Scene Photography, 54
Custom photo finishing:
 training and job
 requirements for, 91–92;
 special services provided by,
 90–91

D

Demonstration videotape,
 preparation of, 84–85
Duncan, David Douglas, 57

E

Editor and Publisher, 63
Ensign-Caughey, Diane, 103–4

F

FBI Crime Laboratory of
 Forensic Photography, 51
Fine art photography: definition
 of, 100–1; estimation of
 costs and pricing, 102–3;
 sales to magazines, 106; sales
 to postcard companies, 105–
 6; sales to poster companies,
 106; training for, 107–8
Fire and Arson Photography, 55
Forscher, Marty, 72–73
Functional Photography, 69

G

Gallery photography: career
 entry methods, 98–99;

evolution of, 95–96
Gowland, Peter, 34

H

Hart, William, 50
Hospital photographic needs,
 68–69
Hospital photography, 68–69

I

*Identification through
 Radiography,* 54
*International Photographer,
 The,* 94

L

Law and Order, 54
Law enforcement photography:
 background and training
 requirements for, 49–54; and
 freelance forensic
 photography, 54; training
 films in, 54
Law Enforcement Training
 Division of Eastman Kodak
 Company, 50
Life, 58
Lowe, Michael, 74–75

M

Magnum, 65
Market guides for
 photographers, 63, 106
Michigan/Ontario Forensic
 Photography Workshop, 51
Model photography: building a

portfolio for, 34–41, 46;
finding customers for, 43,
46–47; locations for, 35–36;
preparing a composite for,
41–42; special techniques
for product photography,
44–45
Model photography equipment,
40
Model photography, types of:
fashion show, 42–43;
magazine illustration, 45–
46; nude and pinup work,
44; public relations, 46;
school, 47
Modernage photo finishing
laboratory, 91
Motion picture photography,
training for, 93–94

N

National Camera, 74–75
New York Times, 66
Newspaper photography, skills
required for, 58
Newsweek, 62

O–P
O'Sullivan, Timothy, 103
Photo finishers' salaries, 93
Photograph mounting, sources
of information on, 102
Photographer's Market, 63, 106
Photographic Surveillance
Techniques for Law
Enforcement Agencies, 55
Photography curatorships,
requirements for, 96–97

Photojournalism: beginning a
career in, 59–63; building a
portfolio for, 59–61;
overseas assignments in, 65;
qualifications for, 59; sales
of to magazines, 62
Police Chief, 54
Portrait photography, freelance:
bookkeeping, pricing and
selling, 7–9
Portrait photography
equipment: backdrop, 6–7;
cameras, 4–5, 10; clamp
lamps, 7; lights, 5; umbrella
reflectors, 6
Professional Camera Repair, 72
Professional Photographers of
America, special seminars
on commercial
photography, 45

R

Ride-along police department
programs for
photojournalists, 64
Rocky Mountain Camera
Repair, 74

S

Scientific photography, training
for, 69–70
Szarkowski, John, 96–97

T

Television camera operators,
types of, 78
Television location photography,
78–79

Television photography: on-the-
 job training in, 78;
 preparation for, 84–85;
 requirements for, 79–84;
 salaries for, 85
Television studio photography,
 78
Time, 62

U–W

United Press International, 62
Wedding photography: billing
 methods, 16–18; customer

finding methods, 20;
 portfolio building, 18–19,
 prices, 12; skills required
 for, 11–12; techniques used
 in, 12–13; training for, 20
Wedding photography
 equipment: cameras, 20–21;
 lights, 21–22; sample
 albums, 22
Weegen, Ernie, 73–74
Weston, Edward, 103
*Where and How to Sell Your
 Photographs*, 63
Writer's Market, 63, 106

Stephanie S. 212 686 1857